HIDDEN
HISTORY
of
RICHMOND

HIDDEN
HISTORY
of
RICHMOND

WALTER S. GRIGGS JR.

THE
History
PRESS

Published by The History Press
Charleston, SC 29403
www.historypress.net

First published 2012

Manufactured in the United States

ISBN 978.1.60949.689.0

Library of Congress Cataloging-in-Publication Data

Griggs, Walter S.
Hidden history of Richmond / Walter S. Griggs Jr.
p. cm.
Includes bibliographical references.
ISBN 978-1-60949-689-0
1. Richmond (Va.)--History--Anecdotes. I. Title.
F234.R557G75 2012
975.5'451--dc23
2012031175

This book is dedicated to my wife, Frances Pitchford Griggs, and to my daughter, Cara Frances Griggs.

CONTENTS

CONTENTS

PREFACE

In the second grade, I wrote my first published work. It was entitled "My Duck." Published in the *Ginter Park Elementary School Messenger*, this masterpiece was as follows:

I had a little duck,
Its name was Quack.
If it does not shut up
I will give it a smack.

My teacher tampered with my verse by using "keep quiet" instead of "shut up." Although the poem did not win a major prize, it did start my writing career. Along with developing a love of writing, I developed an interest in Richmond history. Since I was born in Richmond and have lived my entire life there, I see reminders of historical events every day. In fact, my first trip after I was born was to Chimborazo Park, where I saw the city for the first time. This visit was followed by many trips with my parents and grandparents to see historical places in the city.

As I got older, I only had to drive down Monument Avenue to see the heroes of the lost cause. I began to wonder about Robert E. Lee's claim to fame since I had heard that the well-known historian Dr. Douglas Southall Freeman always saluted the general as he drove by the monument on his way to work. I saw old buildings and tried to find out their original use. I learned that an apartment building was

once a whiskey warehouse and that a ballpark was once the site of the Virginia State Fair. I learned about the collapse of the Church Hill Tunnel and the haunting stories of those still buried in the cold, slimy ground along with the train that will "never be found."

Although the stories in this book range from a car manufactured in Richmond to the tales of the Civil War, they all have one thing in common: the subject matter was very interesting to me. I always tried to write about obscure topics that had tended to fade away over time. For example, I never wrote about the Virginia State Capitol, but I did write a story about a small monument placed by a temperance group and a forgotten hero of World War II.

I would have never written these stories but for the fact that I was asked to write about Richmond for the *Richmond Guide*, a tourist magazine. For more than thirty years, I wrote four stories per year, and I have included many of them in this book. I am grateful to John-Lawrence Smith, the publisher of the *Guide*, for permission to use these stories and to those who worked with him across the years who provided guidance and inspiration. I am also profoundly grateful to my former colleague at Virginia Commonwealth University, Jill D. Kramer, who typed the manuscript. Many of these stories were first typed on a manual typewriter and had to be retyped for the computer. I am deeply in debt to my wife, Frances, for doing all of the proofreading and editing of the manuscript and to my daughter, Cara, for taking many of the pictures. I also want acknowledge the following people who provided information for this book: Fred Nuckols; Robert Kelso Morris; S. Lucille Davis; Bob Harrison; Charles L. Williams, MD; Jim Scott; Charles Enroughty; Teresa H. Mason; Richard H. Glenn; and Evelyn Winbauer Enroughty. I want to thank the following people at The History Press who helped me with the completion of this book: Jessica Berzon, Sophia Russell, Annie Martz, Adam Ferrell, Ryan Finn and Katie Parry. Also, this book would not have a picture in it but for the help of the Ritz Crew at Willow Lawn, including Rebecca, David, Kelly, Chris, Joe and Matt. I owe a debt of gratitude to all of those who have made Richmond such an interesting place to live and to work.

I hope you will enjoy reading these stories and learning more about one of the most fascinating cities on this planet.

Civil War Richmond

Dearest Love, Do You Remember?

In hurried words her name I blest
I breathed the vows the words that bind me
And to my heart in anguish pressed
The girl I left behind me

—author unknown

It was an unpleasant day in Richmond, the capital of the dying Confederate nation, on January 19, 1865. The day was dark and cold with a hint of snow in the air. The weather compounded the misery of Richmonders, who were hungry from lack of food, cold because there was no firewood, distressed with the news of endless military defeats, depressed at the loss of loved ones and unsettled due to gossip concerning problems within the Confederate government. Yet amid the gloom of a dismal day, there was excitement. At St. Paul's Episcopal Church, the church of the Confederacy, a wedding was about to take place between Hetty Cary, a woman known as the "Belle of Richmond," and Brigadier General John Pegram, a handsome, gallant Confederate officer. Their marriage was the culmination of a storybook, wartime romance.

Hetty Cary lived in Baltimore and, on one occasion, waved a Confederate flag from her balcony in front of some Union soldiers. A Union soldier asked his commanding officer if he should arrest her. The

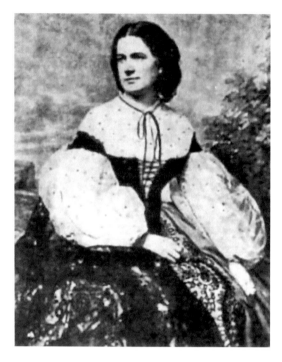

Hetty Cary. *Author's collection.*

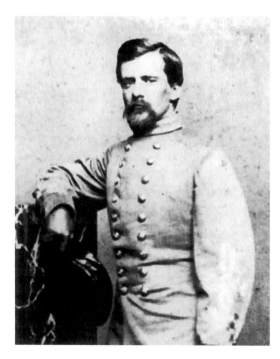

General John Pegram. *Author's collection.*

colonel responded, "A woman that beautiful can do as she pleases." As the war intensified, Hetty fled from Baltimore to Richmond. There her beauty and personality thrust her into the center of the city's social scene and into the hearts of the Confederate leadership. A Confederate officer commented, "If there was no such word as 'fascinating,' you would have to invent it to describe Hetty Cary."

Not only was Hetty Cary a fascinating woman, but she was also an ardent rebel. Hetty and her two cousins made the first battle flags for the Confederate army at the request of a committee of the Confederate Congress. Hetty made her flag out of silk, sewed a gold fringe around it

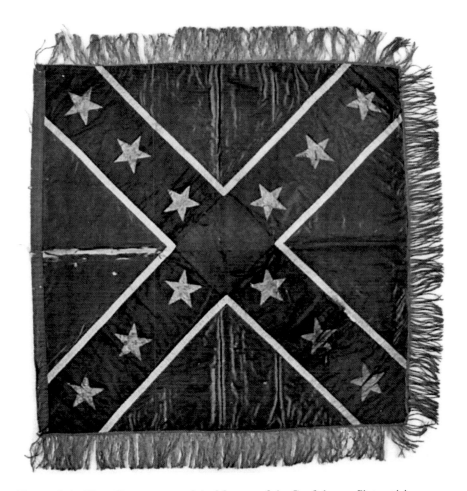

Flag made by Hetty Cary, courtesy of the Museum of the Confederacy. *Photograph by Katherine Wetzel.*

and presented it to General Joseph E. Johnston. In addition to making flags, she gave Starvation Parties to raise money to buy food for the soldiers, she sang at the camps around Richmond to boost morale and, at some point, she met and fell in love with John Pegram.

John Pegram was from a distinguished Virginia family, a graduate of West Point, a military hero and, for three years, the fiancé of Hetty Cary. Their courtship, which included dashing down Franklin Street on their horses and planning their wedding, gave downhearted Richmonders something to gossip about.

Ominously, ill omens preceded their wedding. While showing her wedding veil to an ill friend, Miss Cary broke a mirror. On the night of her wedding, the horses that had been lent to her by Mrs. Jefferson Davis refused to pull the carriage to the church. This unexplained event delayed the wedding until another carriage could be obtained. After the couple arrived at the church, the bride accidentally tore her veil. These occurrences were later remembered by the superstitious.

Arriving late, Miss Cary walked down the aisle of the candlelit church with a slow, stately step. A member of the congregation noted that "her complexion of pearly white, the vivid roses on her cheeks and lips, the sheen of her radiant hair, and the happy gleam of her beautiful brown eyes seemed to defy all sorrow or fear." John Pegram and Hetty Cary stood together in front of the priest and pledged their love to each other with the words "Until death us do part."

The wedding was followed by a brief reception, after which the general and his lady returned to his headquarters, located in an old wooden house outside Petersburg, Virginia. The general needed to be close to his soldiers, who were camped at nearby Hatcher's Run.

Shortly after their wedding, Mrs. Pegram, accompanied by General Robert E. Lee along with Generals Longstreet, A.P. Hill, Gordon, Anderson and Heath, reviewed her husband's troops. It was said that her soul was on fire with the triumph of the moment as the long, gray line of soldiers passed in review. It was a moment when some soldiers saw Hetty Pegram as a returning Joan of Arc. It was a parade in which tattered battle flags were silhouetted against the sky as proud men, gallant men, honored the newly married couple. Mercifully, the general and his lady did not know that they had seen their last review as husband and wife.

On the morning of February 6, a messenger arrived at the general's quarters and warned him that the Union troops were moving to tighten their hold on Petersburg. Hetty quickly made coffee and prepared breakfast for her husband. Before he left, she carefully wound his watch. It was not long before Hetty Pegram was told that her husband had come safely through the battle. Tragically, the news was premature.

While leading a charge later in the day, General Pegram was struck by a Union bullet. He fell from his horse and died on the snow-covered ground. His blood painted the snow red. For John Pegram, the cruel war was over. It was said that upon hearing the news, Hetty turned to stone.

The next day, Hetty Pegram accompanied her husband's body back to Richmond, riding in a cold boxcar next to his coffin. At some point, she removed his watch, which was still ticking—a sad reminder of their last tender moment together. It was commented that Mrs. Pegram was "like a flower broken at the stalk." Her appearance was indicative of a young woman who knew that she would soon have to return to St. Paul's Church as a grieving widow, but a widow everyone still remembered as a lovely bride.

Exactly three weeks after their marriage, General Pegram's coffin, crossed with victor's palms, was placed on the same spot in the chancel of St. Paul's where he had stood to be married. In front of a full church, the same priest who had married the couple read the service for the dead. A diarist noted: "Again St. Paul's has been opened to receive the soldier and his bride—the one coffined for a hero's grave, the other pale and trembling, though still by his side in widow's garb." After the service, General Pegram's body was carried to Hollywood Cemetery. His war charger was led behind the hearse, which was followed by a band whose wailing was never to be forgotten by those who heard it.

At the snow-covered Hollywood Cemetery, the mortal remains of General John Pegram were buried within sight and sound of the James River, while the priest spoke the ancient words "earth to earth, ashes to ashes, dust to dust." His widow and bride lingered at the cemetery for a final farewell. She had been engaged for three years and married for scarcely three weeks. She was still a bride when her husband died—her honeymoon had never ended. And the bitter reality of death can still be felt by looking at John Pegram's grave in Hollywood Cemetery and remembering that the love of Hetty's life was no more.

Eventually, Hetty Pegram remarried. When she died, she was buried in Maryland, a long way from the bitter memories of Richmond but still linked in love to the man whose life ended on a battlefield called Hatcher's Run. Perhaps these words from a Civil War song best capture the bittersweet romance of Hetty and John:

Weeping, sad and lonely,
hopes and fears how vain!
When this cruel war is over,
praying that we will meet again.

GENERAL T.J. JACKSON GOES TO CHURCH

You can be what you resolve to be.

—*T.J. Jackson*

Sunday, July 13, 1862, was a lovely summer day in Richmond, Virginia, the bustling capital of the new Confederate nation. Since the beginning of the War Between the States, the city had become filled with government officials and military leaders. Its many hotels and boardinghouses had become homes for refugees and visitors from across the southland.

Soldiers in gray uniforms, frequently accompanied by ladies in homespun dresses, could be seen walking down the streets. Young couples would also attend Starvation Parties, where they would sing these haunting words:

The years creep slowly by, Lorena,
The snow is on the grass again.
The sun's low down the sky, Lorena
The frost gleams where the flow'rs have been.

On this Sunday, Richmonders were feeling a sense of relief. The Seven Days' Battles, which had saved Richmond from the Union army, had been won, but the costs were staggering. Dead soldiers in tattered uniforms of blue and gray were strewn across battlefields at Mechanicsville, Gaines's Mill, Savage Station and Malvern Hill.

In Richmond, makeshift hospitals were filled with those whose bodies had been torn apart by rifle bullets, hacked to pieces by swinging sabers or blown asunder by cannonballs. The smell of chloroform was everywhere, as were amputated limbs that had been tossed out of the hospital windows. Nurses were slowly and tenderly placing the hands of the dying into the hands of God.

Many women were dressed in black as they went to one of Richmond's many churches to seek comfort for the loss of their loved ones. Their hands were folded as they prayed for the immortal souls of those who had been loved and were now lost. In nearby cemeteries, the gravediggers worked day and night. Soon, many mounds of red clay were piled up to mark the final resting places of the men who had died in defense of the Confederate nation. But the battles to save Richmond had been won, and the Confederate banner still fluttered in the southern breeze. There was still hope for the independence of the new nation.

Part of this optimism was based on the successes of the two Confederate generals, Robert E. Lee and Thomas J. "Stonewall" Jackson, who were meeting with Virginia governor John Letcher early on this Sunday morning. Following the meeting with the governor, they rode to the White House of the Confederacy to meet with President Jefferson Davis. The purpose of the conference was to plan for Jackson's future engagements with the enemy.

Captain Charles Blackford, who saw them, commented on the appearance of the two generals in a letter: "Lee was elegantly dressed in full uniform, sword and sash, spotless boots, beautiful spurs, and by far the most magnificent man I ever saw." Remembering Jackson, though, he recalled:

> [Jackson] *was poorly dressed although it appeared that his clothes were made of good material. His cap was very indifferent and pulled down over one eye, much stained by weather and without insignia. His coat was closely buttoned up to his chin and had upon the collar the stars and wreath of a general. His shoulders were stooped. He had a plain swordbelt without sash and a sword in no respect different from that of other infantry officers that I could see. His face is not handsome or agreeable and he could be passed by anyone without a second look.*

Jackson might not have dressed, or even looked, like a general, but on this Sunday morning, he was one of the South's greatest heroes. But there was more to this man than his dress. Thomas Jonathan Jackson was born into a poor Virginia (now West Virginia) family; he had graduated from West Point in spite of the fact that he did not have the normal academic preparation for the school. He had served in the Mexican-American War, he had been a professor at the Virginia Military Institute and he was guided by the maxim "You can be what you resolve to be."

When the conference with the president ended, General Jackson mounted his horse and headed west from the White House toward Richmond's Second Presbyterian Church on Fifth Street. It is not known which route Jackson took to the church, but it is likely that he tied his horse to a tree at Main and Fifth Streets. Leaving an orderly to watch the horses, he walked to the nearby church accompanied by several staff officers. Arriving late and while the congregation was singing a hymn, he probably slipped into a side door and was seated in a side pew near the back

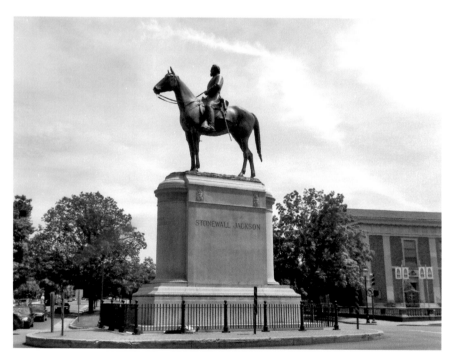

The Thomas J. "Stonewall" Jackson Monument on Monument Avenue. *Photograph by Walter S. Griggs Jr.*

of the church along with his staff officers, including Dr. Hunter Holmes McGuire, Lieutenant Alexander S. "Sandy" Pendleton, Captain Henry Kyd Douglas and Captain Hugh A. White of the Stonewall Brigade. Since he arrived late and was dressed in the plainest of uniforms, most members of the congregation probably did not recognize the presence of the famous general and devout Presbyterian.

Conducting the service was Reverend Dr. Moses Drury Hoge, who had founded the church. Dr. Hoge, "a tall, spare, muscular man with a military physique," was the honorary chaplain of the Confederate Congress and frequently visited and preached to the Confederate soldiers camped in and around Richmond. Before preaching, he would drape his long arms "around the pulpit Bible and his long neck would seem to grow longer as he peered over his collar and cravat to take the measure of his audience." His voice was described as "one in a million," and by all accounts, he was one of the best preachers in Virginia. However, Jackson, although deeply religious, apparently went to sleep during the service and slept through the greater part of it.

Maybe the exhausted general only appeared to be sleeping. Perhaps he was pondering his favorite Bible verse, Romans 8:28: "And we know that all things work together for good to them that love God, to them who are called according to his purpose." Or maybe he was recalling the days long past when he would sing "Amazing Grace" in the Sunday school he had conducted in Lexington, Virginia, for the children of slaves. Or maybe he just slept.

Dr. Hunter McGuire, who was the staff surgeon in Jackson's command, commented that "a person who could go to sleep under Dr. Hoge's preaching can go to sleep anywhere on the face of the earth."

When the service ended, members of the congregation suddenly became aware of the famous visitor in their midst. Some members climbed over the pews to get near him. Other members filled the side aisle in order to see the general who had earned the name "Stonewall" at the Battle of First Manassas and who had confounded the Union army in the Shenandoah Valley.

Soon the general and his staff were forced into the back corner of the church, trapped. The church members had done what the Union army could not do: they had cornered "Stonewall" Jackson. One observer commented that "the general seemed uneasy, he really appeared

confused." When Jackson and his aides finally got outside the church, "a lady, evidently an old friend, came up, seized the general by the arm, and hurried him down the street."

According to some accounts, General Jackson left the church and went to a nearby house to "call on a mother who had lost a son." Such a visit would have been in keeping with General Jackson's concern for the men under his command. If he made the visit, it was very brief. Within fifteen minutes, he had rejoined his waiting staff and returned to his army, which he called the "Army of the Living God."

But Jackson could not forget the service at Second Presbyterian, and on July 14, he wrote to his wife about the service: "Yesterday I heard Doctor M.D. Hoge preach in his church and also in the camp of the Stonewall Brigade. It is a great comfort to have the privilege of spending a quiet Sabbath within the walls of a house dedicated to the service of God. People are very kind to me. How God, our God, does shower blessing upon me, an unworthy sinner!"

On that same day, Captain Hugh White wrote to his father, the minister of Lexington Presbyterian Church, about the service: "Yesterday I went to Richmond and had the pleasure of hearing Dr. Hoge preach. I enjoyed the service greatly. General Jackson was present and immediately after the benediction, all eyes were turned upon him, and the crowd gathered uncomfortably close about him."

General Thomas Jonathan Jackson would never again attend services at Second Presbyterian Church. Within a year of his attendance, the mighty Stonewall was dead, in spite of the best efforts of Dr. Hunter Holmes McGuire, who had attended the service with him. As he met the God he served, he was heard to say, "Let us cross over the river and rest under the shade of the trees." For Thomas Jackson, the cruel war was over.

Of the staff officers who had attended church with him, only Dr. Hunter McGuire and Henry Kyd Douglas survived the war. Dr. McGuire became Richmond's most well-known physician, and Henry Kyd Douglas became a successful attorney in Hagerstown, Maryland.

Captain White, who had planned to study for the ministry, died at the battle of Second Manassas while leading his men. The Southern Cross on the Confederate flag he was carrying fell across his lifeless body. His last words to his men were, "Come on, come on!" Alexander

"Sandy" Pendleton of Jackson's Staff accompanied the general's body to Lexington for burial. Returning to Confederate service, he was killed at Fisher's Hill. His final words were, "It is God's will, I am satisfied."

Today, a small plaque marks one of the pews where General Jackson and his staff sat to worship in Second Presbyterian Church. Given by the United Daughters of the Confederacy, it is inscribed: "General Thomas J. (Stonewall) Jackson, C.S.A."

If you look carefully, it is still possible to imagine a group of Confederate officers quietly entering through the side door of the building and being seated near the back of the church in a side pew. With a little imagination, you can almost see the ghost of a general in a tattered gray uniform bowing his head in prayer in the dimly lit sanctuary.

Perhaps, if you listen carefully, you can still hear Dr. Hoge preaching the gospel and invoking the love of God. Maybe with one final glance, you can still see the image of a general trying to sing his favorite hymn, "Amazing grace, how sweet the sound that saved a wretch like me."

JEWISH SOLDIERS OF THE SOUTH

Hear, O Israel: The Lord is our God, The Lord is One.
—Deuteronomy 6:14

In April 1861, Fort Sumter in Charleston Harbor was attacked by forces of the newly created Confederate nation. This attack plunged the United States into the American Civil War. Men across the South grabbed their muskets, put on their sabers and rallied around the Southern banner as war swept across the land. Among those who put on the uniforms of gray were Jewish men who felt that they needed to fight to defend their homes and families as their ancestors had done in Jericho, Jerusalem and Masada.

These Jewish Confederates fought at the Shiloh Meeting House, the Wilderness, the Bloody Angle, Sharpsburg, Vicksburg and Gettysburg, to name only a few battlegrounds. To provide a final resting place for the Jewish dead who had marched through the "Valley of the Shadow of Death," a Jewish military cemetery was established in Richmond. According to many historians, this is the only Jewish military cemetery outside of the nation of Israel. It is a space set apart in the much larger

Hebrew Military Cemetery. *Photograph by Walter S. Griggs Jr.*

Hebrew Cemetery, located at Hospital and Fifth Streets, and holds the remains of thirty Jewish soldiers who died fighting in Virginia.

Who were some of these men laid to rest in this sacred place? Captain Jacob A. Cohen, Company A of the Tenth Louisiana, was killed at the Battle of Second Manassas while fighting under the command of General Robert E. Lee. He was one of many Jewish officers who served the South, as was Lieutenant L.S. Lipman of the Fifth Louisiana, who died at Chancellorsville. He probably never knew that his commanding officer, General Thomas J. "Stonewall" Jackson, would die as a result of wounds received in the same battle.

In June 1864, anxious people stood within sight of this cemetery to hear the sounds of thundering cannons coming from the Battle of Cold Harbor, east of Richmond. One of the Confederate soldiers who died in that battle was listed as Private Henry Gersberg of the Salem Flying Artillery. He died in the arms of a fellow Confederate soldier. The muster roll stated that he was buried in the "Jews' burying

ground, Richmond, Virginia." It took years of research for the son of the man who cradled this dying soldier to determine that the man's correct name was Henry Gintzberger.

There are also soldiers buried in this cemetery about whom little is known, including J. Rosenberg of Georgia, Sam Bear (likely a misspelling of Baer) of Georgia, J. Frank of Georgia, M. Levy of Mississippi, G. Wolfe of North Carolina and A. Lehman of South Carolina. There is also one soldier whose identity has been listed simply as "Unknown." Jewish soldiers from Virginia buried in the cemetery were few in number: Henry Adler, who enlisted in Richmond and was a member of the Forty-sixth Virginia; J. Hesseberg of the Third Virginia Infantry; Gintzberger of the Ninth Virginia; S. Bachrach of Lynchburg; Isaac Seldner of the Sixth Virginia; and M. Bachrach of Lynchburg.

General Robert E. Lee acknowledged the importance of the Jewish soldiers to the Southern war effort when he wrote, in response to a request by Rabbi M.J. Michelbacher (of Richmond's Temple Beth Ahabah) for a furlough for Jewish soldiers to observe the Jewish Holy Days, "I will gladly do all in my power to facilitate the observance of the duties of their religion by the Israelites in the army," but he could not permit them to leave the ranks for the observance since they were needed to defend the South.

In 1864, unable to come home to Richmond, Isaac J. Levy of the Richmond Blues wrote to his sister, Leonora, that he had observed Passover in "truly Orthodox style" while stationed at Adams Run, South Carolina. He died a few months later in a trench at Petersburg. A family friend described him as a "true Israelite without guile—a soldier of the Lord and a soldier of the South."

Initially, the Confederate graves in the cemetery were marked with tombstones, but the passage of time made the stones illegible. These old stones were removed during the 1950s and replaced with a permanent marker etched with a Star of David to symbolize the faith of those who fought under the Stars and Bars. The marker is inscribed, "To the Glory of God and in memory of the Hebrew Confederate soldiers resting in this hallowed spot." Following this inscription, the names of those buried in the plot are listed—including Henry Gintzberger's, added in 1963.

Today, a person can visit this sacred place and reflect on the sacrifices of those men of the Jewish faith who fought and died for the cause in

which they believed. Stones placed atop the marker indicate that visitors still come to pay their respects to these men. Occasionally, a dove will land on the monument to the fallen as if to remind us that the dove still carries the ancient hope of peace on earth when wars will be no more. Perhaps if you close your eyes and reflect on the rich history of the Jewish people, you will hear these sacred words: Shema Yiswrael, Adonai eloheinu, Adona echad (Hear, O Israel, the Lord is our God, the Lord is One).

THE FADED DOVES OF RICHMOND

If you are looking for love, find a Faded Dove.

−*WSG*

Richmond has many reminders of the Civil War. There are monuments that honor the heroes of the lost cause, remains of trenches in which soldiers fought and died and buildings that once housed the leaders of the Confederate nation. However, Richmond has no monuments or tributes to the "faded doves" who flocked to Richmond in droves during the Civil War and perched in houses, hotels and even back alleys.

What was a faded dove? It was a polite synonym for a prostitute. And to put the matter in perspective, during the Civil War, it was said that Richmond had more faded doves than New Orleans and Paris combined. A newspaper reported that "Richmond was a second Sodom," and a Confederate soldier stationed near Richmond wrote, "If there is any place on God's fair earth where wickedness stalketh abroad in daylight, it is the army." Perhaps this is why there are no monuments to the numerous flocks of faded doves who roosted in Richmond.

Who were these women? Newspapers usually did not publish the names of these wayward souls who had been arrested by the local sheriff. The omission was justified by stating that "their names we omit as of no earthly interest to our readers." I wonder! In another case, a reporter explained, "As the particulars would only minister to a morbid appetite, our readers must content themselves with this brief mention."

However, there were occasions when a flock of faded doves nesting in Richmond were arrested and their names were reported to the public, including the following: Emma Marsh, Zella Glenman, Ella Johnson,

Mary E. Vanderlip, Sarah Jane Rose, Amanda Logan, Ann E. Thomas, Clara A. and Mary Moose, who seemed to have been always loose since she paid her fines and continued to seduce. The authorities described these captured women as follows: "[S]hallow-faced, dope–drugged, booze-sotted harlots of the most desperate sort." The newspapers reported that the women who were arrested "were under thirty and were of the vilest character, the dirtiest person and the most brazen face." In another case, a *nymph du pave* (a beauty of the street) who had been arrested for various sinful acts appeared in court "as smiling as a basket of chips."

The language of the 1860s was quite genteel and obscured not only the true vocation of the ladies but also the many places where they were located. The following phrases were used in the newspapers: "house of ill-fame," "resort for lewd females," "disorderly house of ill-fame," "house of evil-fame" and an "ill-governed and disorderly house." In one case, the mayor of Richmond called a certain house a "nest of vile and unclean birds."

Faded doves nested in a variety of buildings, six of which were very close to the Confederate capitol building. And it should be noted that all locations were not created equal. Josephine DeMerritt's nest had almost a dozen doves and catered to the well-to-do Confederates, which seems to have kept her immune from interference by the police.

Other locations were close to hospitals so patients could leave the hospitals, have a pleasant evening and then hobble back on their crutches to their beds. It might be suggested that if the soldiers were really sick, how could they escape from the hospital to seek treatment through the use of nontraditional medication? There were also nests near and in hotels, military installations and the YMCA. In addition to these locations, there were areas known by such names as the following: Solitude, Sugar Bottom and Pink Alley. It was observed that the ladies would smile, bow, wink, gesture and smirk in order to attract the attention of potential customers. But there is no evidence that they cooed like real doves to solicit business.

Puritanical Richmonders were shocked and appalled by the lewd and lascivious conduct that was going on around them. Like hungry hawks, they went on the offensive against the sinful activities of these wayward birds. The Richmond paper reported, "The work has commenced in earnest. Modest virtue may now lift its eyes and smile sweetly at the coming of the long promised millennium. Richmond is to be purged of vices that have started forth from dark and lonely hiding places, and

sailed on obscene wings athwart the noon." Following a raid on a house of ill-fame, the paper reported, "It has been suggested that the divine example furnished advice to the penitent Magdalene will be imitated in this instance—go and sin no more." In one case, a man prayed for the forgiveness of the sins of the woman he had just led to sin. But the doves continued to flock into the city and sin evermore.

When arrested, the women were generally fined about $150 and then allowed to return to recoup their losses. But there were cases where they were whipped or put in jail. In one case, a Confederate officer jailed some women overnight and commented that they would have the chance "to commune with their own thoughts." It was believed that the doves had to be confined because "once at liberty, they follow and hover in the path of an army, like carrion crows that snuff a field of slaughter."

Following the war, these women switched their loyalty and started cavorting with men in blue uniforms. Could it be suggested that the ability of the doves to embrace both the blue and the gray was the first step in reuniting our nation?

Although there are no memorials in their honor on Monument Avenue, I am sure that if you watch one of the monuments, you will see a loving dove perch on it. Perhaps you will reflect on those days long past when faded doves migrated to, and nested in, many of Richmond's buildings, providing aid and comfort to the soldiers in gray and then to those in blue.

James Ewell Brown Stuart: The General Who Gave His Life to Save Richmond

Oh God, where [ever] my footsteps stray
For prairies far for battle din
Still keep them in thy holy way
And cleanse my soul from every sin.
Lord, when the hour of death shall come
And from this clay my soul release
Oh grant that I may have a home
In thy abode of endless peace.

—Brevet Second Lieutenant J.E.B. Stuart

Virginia is beautiful in the springtime. Songbirds sing their melodies of love, dogwoods brighten the countryside and the spring breezes refresh the spirit. But the spring of 1864 was different. The Union army was marching across the Virginia landscape in an effort to defeat the Confederate forces and end the Civil War. In that troubled year, most Virginians did not have time to take notice of the spring flowers that were being trampled underfoot by marching soldiers, galloping horses and rolling wagon wheels.

Richmonders were especially concerned in May 1864 because the Union forces were surging ever closer to the city. And their concerns were justified. North of Richmond, the Union cavalry under the command of Major General Philip Sheridan was on the attack. As the men and horses swept toward Richmond, the tattered Confederate army maneuvered to block their path in an effort to save the city.

In the forefront of the Confederate forces was their cavalry, under the command of Major General James Ewell Brown Stuart. He and his cavalry personified the excitement, the passion and the pride that characterized the cavalier spirit of the cavalry of the Army of Northern Virginia. Stuart was dressed for battle. A contemporary wrote, "His fighting jacket shone with dazzling buttons and was covered with gold braid; his hat was turned up with a golden star and decorated with an ostrich plume; his fine buff gauntlets reached to the elbows; around his waist was tied a splendid yellow silk sash; and the spurs were of pure gold." He had piercing blue eyes, a full beard, an athletic figure and a zest for life. Truly, he was Virginia's cavalier.

On May 10, 1964, Stuart was in close pursuit of the Union army north of Richmond when he took time visit to his wife, Flora, and their two children. Not having time to dismount from his horse, he leaned over and kissed Flora and then rode away. As he rode, the general was quiet, reflective and morose. He commented to an aide that he did not expect to survive the war. Was he having a premonition of his death? Did he sense that he had seen his wife and children for the last time? The music of life seemed to have left his soul.

The following day, Stuart was at a place called Yellow Tavern in the vicinity of Telegraph Road, north of Richmond. At 4:00 p.m., the Union forces attacked, led by the flamboyant Brigadier General George Armstrong Custer. The men in blue managed to capture some

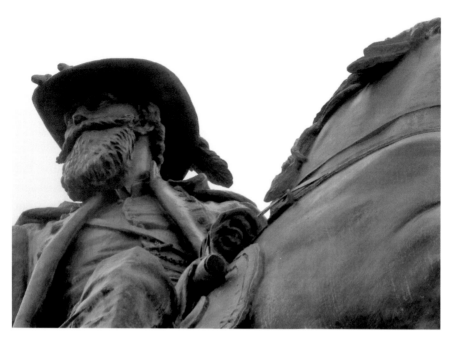

General James Ewell Brown Stuart. *Photograph by Walter S. Griggs Jr.*

Confederate artillery pieces and then dashed toward Stuart and his men. General Stuart pulled out his pistol and fired at the charging Federals. A soldier near the general expressed concern for the general's safety since he was such an easy target. The general responded, "I don't reckon there is any danger." Stuart continued to fire his revolver until it was empty. As the Federals swept ever closer, Stuart ordered, "Steady men, steady; give it to them!" Some Confederates reported that the general was whistling during the battle.

The Federals withdrew, but not before a dismounted Federal fired a bullet that tore into Stuart's side. The general's head dropped, and his hat fell to the ground. Since Stuart's revolver was empty and because he would never retreat, he received the fatal wound without being able to defend himself. One shot from the pistol of Private John A. Huff of the Fifth Michigan Cavalry, a soldier who had been recognized as an expert marksman, had found its mark. An aide asked the general if he had been wounded badly, and Stuart responded, "I am afraid I am."

In excruciating pain, Stuart could not control his horse and asked to be helped down. Carefully, he was placed on another horse and led to a place of safety, where he awaited the arrival of an ambulance. While being taken from the battlefield in the ambulance, General Stuart saw some Confederates retreating. Summoning his ebbing strength, he ordered, "Go back, go back and do your duty, as I have done mine and our country will be safe!" Then he said, "I would rather die than be whipped!"

Since many roads were blocked, the general's ambulance used a lengthy route to reach Richmond and the home of his brother-in-law, Dr. Charles Brewer, at 206 Grace Street. While being attended by physicians who were powerless to save him, General Stuart began his lonely journey through the "Valley of the Shadow of Death."

In lucid moments, he gave away his personal possessions, including his horses, spurs and sword. The general was getting his earthly affairs in order. But he was still torn between this world and the next. When General Stuart heard the thunder of cannon fire, he was told that the Confederates were trying to trap the Federals. He prayed, "God, grant that they may be successful." Then he said, "But I must be prepared for another world."

As Richmonders gathered outside the house to pray and to wait, President Jefferson Davis entered the general's room and grasped his hand. Responding to a question from the president as to his condition, General Stuart responded, "Easy, but willing to die if God and my country think I have fulfilled my destiny and done my duty." Soon, the president left. The deathwatch continued.

Stuart was in agony. He was delirious, and in his delirium, he shouted orders to soldiers he could only see in his mind. Perhaps he recalled the long, gray line at West Point, the service in the West, the daring ride around General George B. McClellan's army or the carnage at Gettysburg. Holding ice against his abdomen to relieve his pain, he asked for his wife, but she had not yet arrived. He struggled to stay alive so that he could see her just one more time. But it was not to be. He could no longer ignore the call of the angel of death.

Gathering his strength, General Stuart asked his physician how long he might live. His physician candidly responded that "death was near." As the pain increased, he asked for the attending clergy to sing these lines:

Rock of Ages, cleft for me,
Let me hide myself in Thee;
Let the waters and the blood,
From Thy wounded side which flowed,
Be of sin the double cure;
Save from wrath and make me pure.

The dying general tried to sing these comforting words, but his breath was fleeting—the words would not come. After saying, "I am resigned; God's will be done," he breathed his last breath. In a room filled with friends, physicians and clergy, the gallant Stuart joined the army of Confederates that had passed on before him. Upon hearing about his death, a Richmonder wrote, "It seemed, indeed, very difficult to realize that General Stuart, late so full of life, so bright, so brave, could be cut down in a moment."

About three hours after his death, Flora Stuart finally arrived at her husband's bedside. She was too late. The weeping sounds in near silence told her so. Her last memory of the man she loved would be a parting kiss—not a deathbed embrace.

On May 13, the general's funeral was held at St. James's Episcopal Church at the corner of Marshall and Fifth Streets. While the organ sounded a funeral dirge, the general's coffin, draped with a Confederate flag, was carried up the center aisle of the church and placed before the altar. Judith McGuire wrote, "At the head of the coffin sat the soldier who had rescued him and nearby, the members of his staff, who all adored him." In attendance were the leaders of the Confederate nation, as well as Richmonders who had come together to pay their last respects. The funeral service was conducted by Reverend Dr. Joshua Peterkin, the rector.

Following the service at the church, the mortal remains of General James Ewell Brown Stuart were placed in a hearse decorated with black plumes and pulled by four white horses to Hollywood Cemetery. Since all available soldiers were deployed to defend the city, there was no military escort. President Davis, as well as a large number of civilian and military leaders, followed the courageous Stuart to his final resting place in the cemetery.

Reverend Dr. Charles Minnigerode of Saint Paul's Church, in a very strong German accent, conducted the service of committal, which concluded with these words: "The grace of our Lord Jesus Christ, and the love of God, and the fellowship of the Holy Ghost, be with us all evermore. Amen."

Flora Stuart dressed in widow's weeds for the rest of her life. When she died in 1923, she was buried next to her husband on the fifty-ninth anniversary of his death. They were now together again. On their tombstone is an inscription: "They so lived in this life that in the world to come they have life everlasting."

Although death ended Stuart's life, it did not end his legacy. Even today, his memory lives in the obscure byways of Virginia, where one can still imagine the gray-clad ghosts of Stuart and his men riding their horses on a raid with sabers clanging, pistols loaded, carbines at the ready, the Southern cross floating over their heads and singing, "If you want to have a good time, jine the cavalry."

DUTY DONE: THE LEGACY OF ROBERT E. LEE

You will take with you the satisfaction that proceeds from the consciousness of duty faithfully performed, and I earnestly pray that a Merciful God will extend to you his blessing and protection.
—General R.E. Lee

More than one hundred years ago, the equestrian statue of General Robert E. Lee was placed on Monument Avenue in Richmond, Virginia. This monument, erected at a time when Richmonders still recalled the deep despair of Appomattox and the agony of Reconstruction, symbolized the South's respect for and devotion to Lee, the beloved commander of the Army of Northern Virginia during the War Between the States. Although this monument depicted the physical being that was Robert E. Lee, no statue could capture the inner qualities of the man whose very life personified a devotion to Virginia and the South.

This devotion was prompted by Robert E. Lee's commitment to duty. For his own personal reflection, he once wrote, "A true glory and a true honor: the glory of duty done." While a colonel in the United States Army, he was confronted with a dilemma that must have wrenched his soul. With a "Yes, Sir," he could have received the command of the Union forces that would invade Virginia and seek to halt secession. Yet duty required him to return to Virginia and cast his lot with his native state.

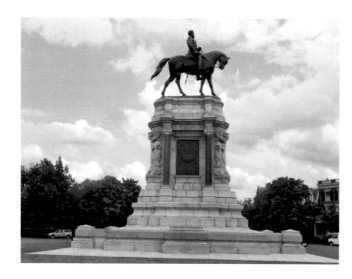

The Robert E. Lee Monument on Monument Avenue. *Photograph by Walter S. Griggs Jr.*

Once home, duty led him to reluctantly accept the command of the Virginia forces with the words, "I devote myself to the service of my native state, on whose behalf alone I will ever again draw my sword." Now, the former United States Army colonel was a Confederate general committed to directing Virginia's forces against the nation that he had loved and served. Robert E. Lee had weighed both of these decisions in light of his concept of duty and had selected a difficult, if not tragic, course for his life.

Lee's sense of duty guided him throughout the war. At the Battle of Sharpsburg, fields turned red with blood, and the songs of birds were obliterated by the thunder of cannon fire, the whine of Minié balls and the screams of the dying. Amid the hell of this battle, General Lee saw a cannon being removed from the lines. The young cannoneer assigned to the gun asked General Lee if they would have to return to the battle. General Lee responded, "Yes, my son!" Indeed, it was his own son whom the father ordered back into battle. Father and son fulfilled duty's requirements: one as a general, one as a private and both as men of rare courage.

At Gettysburg, the Old South died. Pickett's Charge was crushed by Union steel on Cemetery Ridge. Lee believed that it was his duty to accept full responsibility for this carnage when it would have been easy, and appropriate, to place the blame elsewhere. He could have blamed the Confederate government for lack of support or his subordinates for failure to carry out his orders. Yet when the defeated but defiant Army of

Northern Virginia returned to him, he could only say, "It is I that have lost this fight." Duty and accountability coalesced in the life of General Lee.

It was also at Gettysburg where a wounded Union soldier saw the general and shouted, "Hurrah for the Union!" Lee was not offended. Instead, he halted his horse, dismounted, shook the wounded man's hand and said, "My son, I hope you will soon be well." Duty was moderated by compassion for General Lee. He could order his own son into battle, but he could also stop and wish someone else's son a rapid recovery.

The cruel war ground on for almost two years after Gettysburg before it mercifully ended. At Appomattox Court House, General Lee's values were given their test. The general had to weigh all of his military options and determine the proper course. Some officers wanted to continue the fight, while others advocated guerrilla warfare or even surrender. The agony of this decision-making process must have permeated every fiber of his being. Finally he said, "I will go to see General Grant and will take the consequences of my act." These words must have been difficult to speak, and the mission must have been horrible to execute. Yet General Lee performed his duty. He met General Grant and surrendered his army. Although this meeting was difficult, it must have been even more brutal to answer in the affirmative when his own soldiers cried, "Are we surrendered?"

Robert E. Lee did not shirk his duty, and he gained the affection of his men. Indeed, his last order to his army contained the phrase "you will take with you the satisfaction that proceeds from the consciousness of duty faithfully performed." Duty's requirements were harsh, but their fulfillment allowed his battered and defeated men to maintain pride in themselves at a time when they had lost everything.

After Appomattox, Lee's code of conduct would not let him escape his obligation to his people. He set a positive example for the South by leading young men down the difficult road to peace and reunion. To accomplish this, he spent his final years as president of Washington College (now Washington and Lee University). As president, he felt that duty's requirements could only be met by encouraging students to stay in college until they graduated. He saw no merit in simply enrolling students and then letting them drop out. Robert E. Lee saw this duty as a commitment to help others.

Lee also set an example for the South in another way. An old legend recalls an uncomfortable moment at St. Paul's Church in Richmond when a former slave walked to the front of the church to receive communion.

The congregation was startled, but soon Robert Edward Lee walked to the front of the church and knelt next to the former slave. These two men knelt together before God and then stood up together for a new and united nation.

Robert E. Lee lived his life in light of his duty to his fellow man and won the respect of all Americans; this respect has transcended the ages. Yes, Lee's equestrian monument is an artistic work, but it should also remind all who see it that true glory is in duty done.

THE RETURN OF THE CONFEDERATE DEAD FROM GETTYSBURG

Carry me back to Old Virginia.
—adapted from the former state song of Virginia

On November 19, 1863, President Abraham Lincoln spoke these immortal words at the Soldiers' National Cemetery at Gettysburg, Pennsylvania: "Four score and seven years ago, our fathers brought forth on this continent a new nation." These words, which will last as long as this nation endures, were spoken to dedicate a cemetery for the Union soldiers who gave their "last full measure of devotion" on Gettysburg's bloody battlefield. But what honor was accorded the Confederate dead? Where were they laid to rest?

Following the Battle of Gettysburg, the Confederate dead were buried along the roads, shoved into trenches or consigned to common graves. The Southerners were seen as traitorous invaders, and their bodies were not accorded the respect afforded the men in blue. One newspaper reported, "The poor Confederate dead were left in the fields as outcasts and criminals that did not merit decent sepulchers." Their bones were ploughed up by farmers and rooted up by hogs. When a farmer found a human bone, it was generally tossed aside. It was reported that a sign might mark the graves of dead Confederates with the epitaph "58 Rebels here." President Lincoln's words were not spoken over their unattended and unmarked graves.

Reacting to the lack of proper burial for the Southern dead left at Gettysburg, the Southern states launched efforts to return the bodies of their sons to their native states following the end of the Civil War. In Richmond, the Hollywood Memorial Association started a fund drive to secure the money to bring the Confederate dead from Gettysburg

to Richmond for reburial in Hollywood Cemetery. These efforts proved successful, and on June 15, 1872, a steamship docked at the wharf at Rocketts on the James River with boxes containing the mortal remains of the Confederate dead. The soldiers who had left Virginia to fight for a cause that they thought was just had finally come home.

The Gettysburg dead at Hollywood Cemetery. *Photograph by Cara F. Griggs.*

No one will ever know for sure, but one of the precious boxes probably held the unidentified remains of Brigadier General Richard B. Garnett, who was killed while leading his men in what history has labeled Pickett's Charge. This charge, which took place on the afternoon of July 3, 1863, began when General George E. Pickett ordered his men forward with the cry, "Charge the enemy and remember old Virginia." More than thirteen thousand Confederate soldiers emerged from the woods on Seminary Ridge and headed toward the waiting Union forces on Cemetery Ridge, which was nearly one mile away. The charging Confederates could see the Union muskets lined up like so many broom handles. It takes a certain kind of courage to charge into a loaded musket. Pickett commanded, "Forward! Guide center! March!"

Union shot and shell tore into the marchers, but still they came. It was recorded that the battle noise was "strange and terrible, a sound that came from thousands of human throats like a vast mournful roar." With muskets firing, cannons thundering, flags waving, bayonets fixed and swords pointing forward, the flower of Southern manhood moved forward, ever forward, to the stone wall lined with muskets. The fight was horrific as the Confederates flung themselves across the wall that separated the two armies.

The battle was desperate, the casualties appalling and the Union's fate hung in the balance. But it was the Confederacy that died on that stone wall as the men in gray were repulsed by the Union forces and their bodies were piled up like stacks of cordwood. Their charge had failed. General Garnett, who was ill on the day of the charge, led his men into what was described as a mission to "hell or glory." As he plunged with his men through a hailstorm of lead, Garnett was ripped apart by grapeshot and was left unidentified on a field at Gettysburg.

On June 20, 1872, fifteen wagons were assembled at Rocketts to carry the boxes containing the remains of the Confederate dead. Each wagon was draped in mourning and was escorted by two former Confederate soldiers with their muskets reversed. The funeral procession, which included both political and military leaders of the recently defeated Confederate nation, wound its way up Main Street as it moved toward Hollywood Cemetery. The buildings along the route were draped in black, and they echoed to the plaintive sound of the funeral march. As the wagons passed slowly by, "many eyes were filled with tears and many a soldier's widow and orphan turned away from the scene to shield their emotions."

The procession reached the cemetery, and the boxes were unloaded and buried in a section known as Gettysburg Hill. The soldiers who had escorted the bodies were ordered to "rest arms" as their comrades were laid to rest in Virginia's soil. It was noted in the newspaper that the bodies would remain there until "the great trumpet shall sound."

There was nothing comparable to the Gettysburg Address for these soldiers. There were no memorable orations, only a prayer by Reverend Dr. Moses Hoge of Richmond's Second Presbyterian Church, containing these words: "We thank Thee that we have been permitted to bring back from their graves among strangers all that is mortal of our sons and brothers." Dr. Hoge prayed for those who had survived the war and then intoned, "Engrave upon the hearts of all the young men of our Commonwealth the remembrance of the patriotic valor, the loyalty to truth, to duty, and to God which characterized the heroes around whose remains we weep, and who surrendered only to the last enemy, death."

Following the prayer, three musket volleys were fired in a final tribute to those who were laid to rest for all eternity on Hollywood's sacred hill. The sounds of the muskets echoed across the cemetery, across the River James and across the pages of history. Amen.

TWENTIETH-CENTURY RICHMOND

RICHMOND REMEMBERS THE *TITANIC*

They that go down to the sea in ships, they do business in great waters;
They see the works of the Lord and his wonders in the deep.
—Psalm 107

The cold North Atlantic is unforgiving. Those who "go down to the sea in ships" must respect the power of this body of water. On the night of April 14, 1912, the world's then largest ship, the RMS *Titanic*, was cutting through these cold, icy waters on its maiden voyage to New York. Although the captain knew that icebergs were in the area, he continued to speed through the treacherous waters. Perhaps he had not read the notice posted in the *Titanic*'s chart room that cautioned, "Overconfidence, a most fruitful source of accidents, should be specially guarded against."

In the crow's-nest, high above the magnificent ship, a lookout stared out into the calm sea looking for icebergs. Then he saw it. Frederick Fleet, the lookout, saw an iceberg looming in the ship's path. Quickly he reported to the bridge, "Iceberg, dead ahead." From the bridge, the order was given to stop engines, reverse engines and then make a hard starboard. Quickly, the watertight doors slammed shut. All that could be done had been done. It seemed that the ship would escape disaster, but then it happened. The liner sideswiped the iceberg; six of its watertight compartments were holed. The cold, icy water poured into the ship. A

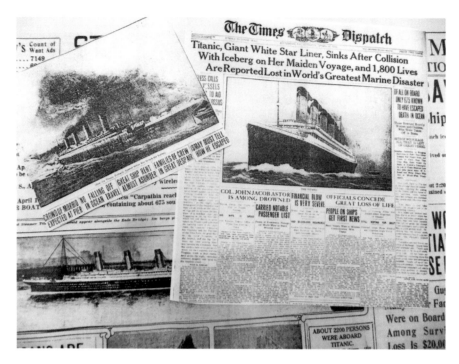

RMS *Titanic*. *National Archives, Washington, D.C.*

mortal blow had been struck. The great luxury liner had been transformed into a ship of death. Its remaining life would be measured in hours.

Realizing that his ship was doomed, Captain Edward J. Smith ordered that a distress call be sent out over the wireless. Soon one of the most famous messages in history flashed across the Atlantic: "CQD MGY I require assistance immediately. Struck by iceberg in position 41 46 N 50 14 W." CQD was the distress call, and MGY was *Titanic*'s wireless identification. Later, the new signal for distress, SOS, would be the last cry of the sinking ship.

As the great ship filled with water, lifeboats were lowered into the cold Atlantic, but there were not enough seats for all the passengers and crew. Following the code of the sea, woman and children were given the seats in the lifeboats. The men whose wealth could purchase railroads or department stores could not buy a seat in a small wooden boat.

With all of the lifeboats gone and death but minutes away, Father Thomas R. Byles stood on the sloping deck and led the doomed

passengers in prayer. The priest's words of comfort were accompanied by the music of the *Titanic*'s band. According to many survivors, the band played the traditional funeral hymn "Nearer, My God, to Thee" as the ship that "God himself could not sink" plunged into the ocean's depth, taking 1,575 souls with it on its voyage to eternity.

Richmonders learned of the disaster in the morning paper. The *Richmond Times-Dispatch* reported on April 16, 1912, in a banner headline, "*Titanic*, Giant White Star Liner Sinks After Collision With Iceberg on Her Maiden Voyage." The *Richmond News Leader*'s headline stated, "1,302 Are Drowned or Missing in *Titanic* Disaster." Another headline reported, "Quietly, Men Wait for Certain Death as Ship Goes Down."

The Sunday following the loss of the *Titanic* became an unofficial memorial day across the nation. In New York City, where *Titanic* was to have docked, Reverend Dr. Charles H. Parkhurst of the Madison Square Presbyterian Church focused on modern life when he declared that "the *Titanic* disaster is the terrific and ghastly illustration of what things come to when men throw God out the door and take a golden calf in at the window." He then painted a graphic illustration when he said that

the picture which presents itself before my eyes is that of the glassy, glaring eyes of the victims, staring meaninglessly at the gilded furnishings of this sunken palace of the sea; dead helplessness wrapped in priceless luxury; jewels valued in seven figures becoming the strange playthings of the queer creatures that sport in the dark depths. Everything for existence, nothing for life. Grand men, charming women, beautiful babies, all becoming horrible in the midst of the glittering splendor of a $10,000,000 casket!

Although somewhat less dramatic in their message, the clergy in Richmond summoned the faithful to focus on the *Titanic* and the lessons that could be learned from the disaster in the North Atlantic. The *Richmond Times-Dispatch* reported that "congregations in every section of the city, from the humble parishes of the industrial districts to the stately cathedrals of the West End, listened in a common bond of human sympathy to priest and pastor." Sermon topics included "The *Titanic* Disaster and Its Message to the Modern World," "The Law of the Sea," "Lessons from the Sinking of the *Titanic*," "Lessons From the Great Disaster" and "God's Providence in the *Titanic* Disaster."

Reverend W.J. Young of the Centenary Methodist Church reminded his congregation that "whatever individual may be primarily at fault, we must all admit that he was, in a sense, a creature of conditions that today are leading us all to clamor for speed, and which have back of them the mad rush to get rich." In closing, he said, "Every lighthouse speaks eloquently of some shipwreck. This method of discovery, this teaching example is itself a law of God."

At Decatur Street Methodist Church, Reverend Mr. Forrester preached on the topic "Save Our Souls," a reference to the distress call of the *Titanic*. He commented that "every passenger on the lost ship had made plans for the future after the arrival in New York…Millionaires, steerage passengers and crew all had decided what course they would pursue after the docking of the *Titanic*. It was improbable, however, if any had left Southampton prepared to die, or with any plans made for such an event." At St. Mark's Episcopal Church, Reverend W. Russell Bowie spoke of the devotion of those who had died on the *Titanic*: "Their glory and heroism caused the beauty of their sacrifice to tower above the shattered wreckage. Life is not measured by its length but by its quality."

Bishop Dennis J. O'Connell at the Cathedral of the Sacred Heart also spoke of the human sacrifice when he said, "The noble heroism of the men who sacrificed their lives to save the weak is an act of religion and piety." He continued that "we are all growing nearer to one another and all nearer to God." At Temple Beth Ahabah, Rabbi E.N. Calisch led his congregation in a moving tribute to the *Titanic*'s dead. He said, "The world will be richer by this disaster by reason of the fine examples of nobility and heroism offered by the men and women on board the sinking vessel."

In many churches, "Nearer, My God, to Thee" was sung during these memorial services. Richmonders had read in the local papers that this hymn was played as the *Titanic* plunged to its grave, and they felt that it was fitting to sing it at the services where those who had died on the ship were remembered. The hymn served to bind the living with the dead in an affirmation of faith. It had provided hope for those who waited to drown when the *Titanic* plunged to its death, it had comforted the survivors in frail lifeboats floating on a sea of the dead and it now sustained a grieving nation with its words of assurance:

Nearer, my God, to Thee, nearer to Thee!
E'en though it be a cross that raisest me;
Still all my song shall be, nearer, my God, to Thee,
Nearer, my God, to Thee, nearer to Thee.

THE GREAT MAIL ROBBERY

You shall suffer death by having a current of electricity pass through your
body until you are pronounced dead and may God, whose laws you have
broken, have mercy on your soul.
 —traditional rendering of the sentence of death

At 8:00 p.m. on the evening of March 8, 1934, Ewell Huband turned his
Federal Reserve mail truck off Broad Street, crossed a railroad bridge and
then stopped for what appeared to be a disabled Plymouth automobile
blocking the road behind Broad Street Station (now the Science Museum
of Virginia). When the driver slowed his mail truck to avoid hitting the
car, armed men leaped from behind a hedge, broke open the back door
of the truck and opened fire on the driver. Even though the truck driver

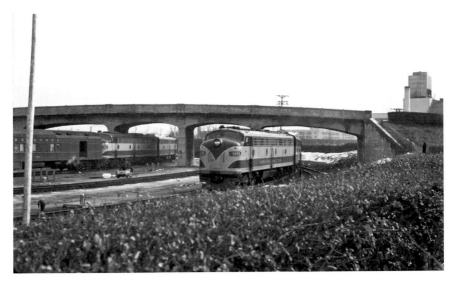

Bridge where the Great Mail Robbery occurred. *Photograph by Walter S. Griggs Jr.*

had made no efforts to resist, four shots from a .38-caliber pistol rang out and Ewell Huband slumped over the wheel—his lifeless body crumpled in death.

Ben Mead, his helper, managed to escape the fusillade of bullets by sliding out of his seat and onto the floor of the truck. The bandits quickly transferred their loot—which consisted only of canceled checks and mail—to their waiting Pontiac automobile and sped away. To complete their escape and confuse police, they abandoned the Pontiac, switched to a truck loaded with egg crates and disappeared. Although it was not known at the time, the killers were members of the notorious Tri-State Gang, a group that even other hoodlums described as devious and treacherous. They were gangsters who killed not only those they robbed but also one another.

The robbers, including the vicious Walter Legenza and the dapper Robert Mais, were eventually apprehended and returned to Richmond to be tried for murder. The testimony given at their trials revealed the sordid inner workings of a criminal gang. Arthur Misunas, a gang member known as "Big Dutch," turned state's evidence and testified that Walter Legenza was "yellow and shot down Huband for no reason at all." Testimony describing the movements of the gang was provided by Mrs. Lenora Gosslyn Fontaine, a gun moll and a former friend of the gang members. The Commonwealth's attorney, in his summation, argued that the "shooting of Mr. Huband was one of the most dastardly and outrageous crimes ever committed in this city, and the electric chair should be pulled out of the State Penitentiary and destroyed if Legenza was not consigned to it." At the end of a series of trials, gang members Walter Legenza and Robert Mais were sentenced to die in Virginia's electric chair, while their accomplices were given long prison terms.

The two condemned men were awaiting execution in the old Richmond City Jail when they received a can of baked chicken or turkey with two pistols hidden inside. On September 29, 1934, Richmond police officer William A. Toot was guarding the door of the jail when he heard shots. When he tried to stop the escape, Mais and Legenza fired four bullets into the officer. The dying officer managed to fire five shots at the fleeing men before he collapsed. Mais and Legenza fled Richmond in a stolen Hupmobile sedan and headed north to resume their criminal careers. After committing a robbery, Mais and Legenza were informed on by other gang members,

captured by police and returned to Richmond guarded by Federal agents with machine guns. This time they would not escape.

The prisoners were assigned to Death Row in the old Virginia State Penitentiary, a few feet from what was callously called the "hot" seat. The two men's last hours were recorded in detail. Their final meal consisted of liver and onions, gravy bread, molasses and coffee. When asked what to do with their personal property, Mais asked that his ring be given to his mother, and Legenza gave a prison official twenty-two cents and suggested that the official might "buy a battleship with it." Legenza also mused that "life is like the throwing of dice, sometimes we win, sometimes we lose, it's all a gamble." He also endorsed the Robin Hood ethic by suggesting that "I never robbed anybody who was poor."

Two chaplains met with the condemned men before their scheduled executions. In an effort to spark a spirit of repentance, one of the chaplains played hymns, including "Just as I Am," "What a Friend We Have in Jesus" and "When the Roll is Called up Yonder," on an English concertina (an instrument similar to an accordion). After the hymns, the chaplains read the Third and Twenty-third Psalms along with the Lord's Prayer. Walter Legenza laughed at the chaplains and rejected all efforts to make his "peace with God," but this was not the case for Robert Mais. He expressed hope that he would meet his spiritual advisor in heaven, acknowledged his sinful past and prayed for divine mercy. He also commented that he "had broken all of the Ten Commandments except he had never killed anyone." The warden suggested that this was "only because he was a poor shot."

On February 2, 1935, at 7:45 a.m., Robert Mais, accompanied by two guards, walked the thirty feet from Death Row to the electric chair. He was strapped in the chair, electrodes were attached to each leg and a copper cap filled with sponges soaked in salt water was placed over his head. Finally, a guard pulled the switch that sent Robert Mais, a repentant man who prayed that the Lord would take his hand, to his fate. Shortly thereafter, the ritual was repeated when Walter Legenza was strapped in the chair and executed. He died an unrepentant man.

After the men were put to death, they were carried to separate Richmond funeral homes where their bodies were put on display. Fourteen thousand Richmonders walked by the gangsters' bodies to get a last look at the notorious men who had spread terror up and down the

Atlantic coast. Obligingly, funeral home attendants showed the curious the scars on the men's legs where the surges of electricity had burned their flesh. One funeral home attendant commented, "I've never seen anything equal to the morbid curiosity of these people. They seem to relish the sight of a dead man. We have had hundreds of mothers bring children, as young as five and six years, with them for a look at the body." (I am not proud of the fact that my grandfather was among the gawkers.)

After the curiosity seekers had been satisfied, the men were buried, their reign of terror ended. The local paper tried to put a positive twist on the executions by suggesting that "Virginia has served its notice to gangsters to give the Old Dominion a wide berth."

DEATH AT DUSK: THE McCARTY-MORDECAI DUEL

When Mary's queenly form I press
In Strauss' latest waltz,
I would as well her lips caress
Although those lips be false.

For still with fire love tips his dart
And kindles up anew
The flames which once consumed my heart
When those dear lips were true.

Of form so fair, of faith so faint,
If truth were only in her;
Though she'd be then the sweetest saint,
I'd still feel like a sinner.

This poem appeared in the *Richmond Enquirer* on February 5, 1873, and provoked Richmond's most famous duel, one that shattered the lives of two men and the beautiful woman they both loved.

The love story began in the early 1870s when Richmond was recovering from the ravages of the War Between the States. Mary Triplett, a woman described as one of the most beautiful women ever created by the Almighty and a reigning belle of Richmond, was engaged to Page

McCarty, a handsome, devil-may-care sort of fellow. Their engagement, however, did not culminate in marriage. Instead, Miss Triplett rejected her betrothed and left Richmond for an extended sojourn in Europe. Upon her return, she would not speak to or have any contact with Page McCarty. He was replaced by a new suitor, the dashing and handsome John Mordecai. Page McCarty was furious.

Sprigg Campbell, "a reckless, bright, audacious fellow," tried to revive the romance between Page McCarty and Mary Triplett. The effort was made at the Richmond German, a popular dance that was held at St. Alban's Hall on the corner of Third and Main Streets. Campbell, for reasons known only to himself, orchestrated a dance figure in such a way as to bring the two former lovers together. The plan was a disaster: after a "turn or two," Mary Triplett left Page McCarty alone on the dance floor and returned to her seat. The rejection could not have been more obvious to all of those at the dance.

Page McCarty, in a state of grief and perhaps rage, composed his poem, and the *Richmond Enquirer* agreed to publish it. Most Richmonders missed the poem's meaning or felt that it was harmless verse, but not John Mordecai. He first read it when he visited Gerots' Restaurant. His rage was immense, and he swore, "I shall kill that fellow." McCarty admitted authorship of the poem but claimed that he was writing about another Mary. In spite of this claim, two duels were planned between the suitors, but friends dissuaded them. The affair might have ended peaceably, but a vicious gossip intervened.

A commentator wrote that "a singularly beautiful and intelligent girl made her tongue busy with insinuations that Page McCarty had backed out of the duels because he was afraid." McCarty heard the gossip, and his rage returned. With his honor in question, McCarty met Mordecai at the bar of the Richmond Club. They exchanged insults and a fight ensued. The fight was stopped but only temporarily; it was to be continued in a more deadly form on the field of honor.

Dueling was illegal in Virginia, but legal niceties did not deter men whose honor had been questioned. The protocol for a duel was followed when Colonel William B. Tabb met John Mordecai in Capitol Square. Colonel Tabb, acting for McCarty, asked John Mordecai to "name his friend." Mordecai complied by naming a person to assist him at the duel.

On May 9, 1873, at six o'clock in the evening on a field behind Oakwood Cemetery near a place called Blakey's Mill, the two suitors

met. Instead of standing back to back, walking ten paces and then firing their weapons at each other, they used a different set of rules. One of those in attendance reported the rules as follows:

> *The terms were that they were to fire at ten paces. The Command would be, "Fire—one, two, three." They could Fire any time after the word "fire," but not after the word "three." The weapons to be used were Colt's Army Revolvers, all six chambers loaded.*

The two former Confederate soldiers appeared fearless as they responded affirmatively to the question "Are you ready?" They stepped off the required paces, turned toward each other, fired their revolvers and missed. McCarty demanded another fire; tragically, Mordecai agreed. Between the count of two and three, two shots rang out, and two men fell to the ground. Mordecai was fatally wounded. McCarty was seriously injured. When the sheriff arrived, both men were lying on the ground being attended by physicians. Other men were gathering fence posts to make stretchers to carry the two wounded men out of the woods.

The dying John Mordecai was carried to the home of his uncle. Although he was in great pain, Mordecai refused the services of a clergyman with the comment, "I shall die as I have loved." He did, however, confide to a friend a message for his sweetheart—presumably the beloved Mary Triplett. He then died having defended his honor and the honor of his beloved. McCarty eventually recovered but would always suffer from his wounds.

Because of Mordecai's death, all of the participants in the duel were arrested. Page McCarty was fined $500, but his six-month jail term was suspended due to his health. In time, all of the other parties were acquitted.

Mary Triplett, the woman loved by both men, was never mentioned in any of the news stories concerning the duel. The code of chivalry did not permit the public linking of a woman's name with an affair of honor.

Miss Triplett did not marry Page McCarty. Eleven months after the duel, she married Phillip Haxall, one of Mordecai's pallbearers. During the years after her marriage, Mary Triplett Haxall was involved in numerous social and civic activities in Richmond. Tragically, the woman whose beauty broke the hearts of two men died of a heart attack at the age of forty-three.

John Jasper: The Preacher Who Moved the Sun

I have finished my work, I'm waiting at the river, looking across for further orders.

—the last words of John Jasper

When you drive into or out of Richmond on Interstate 95, you will notice that the highway makes a slight detour around an old brick church. Named Sixth Mount Zion Baptist Church, it was founded by a black preacher named John Jasper. If you attend a meeting of Richmond's city council, the meeting will be called to order using a gavel made of wood from the house in which John Jasper died. If you talk to a minister who attended the University of Richmond, he might recall a time when ministerial students there were called "Jaspers" in honor of John.

Who was John Jasper? He was a slave who was born on July 4, 1812, in Fluvanna County, Virginia. At the age of ten, he was waiting tables, and at twelve, he was an assistant gardener. His teenage years were spent as a coal miner and a tobacco factory worker. During these formative years, Jasper gave no indication of being a godly man. Then his life changed.

On July 4, 1839, John Jasper was sitting in Capitol Square when he had a strange feeling. He repented of his past sins, converted to Christianity and wanted to preach the gospel like the apostles of old. Since black preachers had to be supervised by white preachers, Jasper was limited as to the churches where he could preach. In spite of this, he served churches in North Carolina and Southside Virginia and conducted services for wounded Confederates in Richmond's Civil War military hospitals.

The Civil War made John Jasper a free man. He continued to preach, and in 1867, he became the first black preacher to organize a church in postwar Richmond. At first, the church was housed in a converted stable on an island in the James River. Shortly, however, Jasper began moving his congregation to larger and larger buildings, because in each case, the congregation outgrew the previous building. His congregations grew because John Jasper was an inspiring preacher.

Although Jasper lacked a formal education, he had learned to read and had memorized most of the Bible. When he preached, he did not give a stilted lecture using detailed notes. Jasper gave a *performance*. His voice boomed, his hands gestured, his message went forth and sinners were

brought to God. Jasper was a fundamentalist who resolved any conflict between the Bible and science in favor of the Bible. This belief led him to preach his most famous sermon.

The stage for the sermon was set when two members of Jasper's congregation asked him whether or not the sun moved. Jasper responded in 1878 by preaching a ninety-minute sermon entitled "The Sun It Do Move." In this sermon, he reminded his flock that Joshua had asked God to stop the sun in order to give him more daylight in which to slay the enemies of Israel. Jasper reasoned that God would not have to command the sun to stop if the sun was standing still already; therefore, the sun does move. Jasper spoke as follows, "I don't say the sun stopped; 'taint for Jasper to say that. But the Bible, the book of God, says so." Jasper believed that God had power over the earth and the sun and could do what he wanted with them. After the sermon, Jasper polled his flock to determine if they were convinced that the sun moved. Jasper won a unanimous vote in favor of his interpretation that the sun does move.

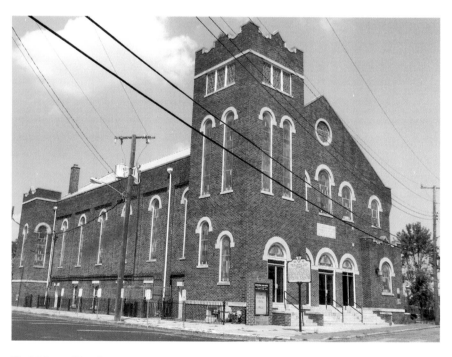

Sixth Mount Zion Baptist Church founded by Reverend John Jasper. *Photograph by Walter S. Griggs Jr.*

This was Jasper's most famous, if not his best, sermon. He preached it 253 times in many southern, as well as northern, cities. Perhaps the ultimate honor occurred when the Virginia General Assembly stopped its session to hear Jasper preach "The Sun It Do Move."

By 1890, Jasper's fame had spread, and once again, his followers had outgrown their church building. Jasper was no longer content to move to another old building and decided to build his own church. His congregation responded with the funds, and Sixth Mount Zion Baptist Church was born.

Jasper was much more than a pulpit orator. He tried to lead his flock through the difficult days of Reconstruction, he developed educational programs, he fostered social service projects and he encouraged good race relations. By the time of his death, John Jasper had preached to more people than any other southerner of his generation.

In March 1901, John Jasper died. This preacher, who was born a slave, died a legend. The Jasper legend was so great that his church was saved from destruction. Indeed, the sun might not move as Jasper suggested, but the bulldozers turned aside to save his church.

SAVED BY A METEOR

Look! Up at the sky! It's a bird! It's a plane! No, it's a man-killing meteor!
—adapted from the Superman *television show*

Somewhere in the depths of outer space, a meteor began its long journey through the solar system. In the night sky, the glowing meteor could be seen as it streaked toward its eventual collision with Earth. Anyone seeing this meteor could not have known the role it was destined to play in solving a murder mystery.

The mysteries of outer space and its hurdling meteors were unknown to Jacob Feitig, also known as Jake Friday, a German immigrant who owned Retreat Farm, located on the edge of Oakwood Cemetery, where he grew vegetables and grapes. During the course of a summer evening in late June, Feitig was reading to Sammox "Mox" Rossdeitcher, a peddler who occasionally visited Retreat Farm and did odd jobs. Feitig had known the Austrian immigrant since his arrival

in the United States as a young boy. Jacob Feitig read to him from the book *Moral Philosophy*. Unfortunately, Mox did not understand the book and soon left the house to sleep in the stable near Oakwood Cemetery. It was July 1, 1890.

The next morning, Feitig went to sell his produce and grapes in Richmond, while his wife went into the barn. There, Mrs. Eva Feitig found Rossdeitcher in the hay with blood covering his head. In the language of the 1890s, he had been "brained." Mrs. Feitig sent a messenger to Richmond to ask her husband to come home immediately. Arriving home, Jacob Feitig took the badly injured man to the Henrico County Poor House, where he was treated for severe trauma to his head. After a few days, Rossdeitcher felt much better and left the poor house and went to Richmond. A few days later, Sammox Rossdeitcher became ill, and he died in the Henrico County Poor House on July 27, 1890. Most likely, he was buried at the Oakwood Hebrew Cemetery, which was in sight of the Feitig farm; Rabbi Harfield conducted the service.

Until his death, no one seemed to pay any attention to Rossdeitcher or his injury, but his death was now a homicide and was turned over to the Henrico County sheriff for investigation. The sheriff's office soon identified four suspects: the horse that was kept in the barn; Jacob Feitig, the owner of the farm; Thomas Sully, a handyman who frequently worked on the farm; and Thornton Adams, who was a boarder in the Feitig home. The horse was considered a suspect since he might have kicked Rossdeitcher; Jacob Feitig was a suspect since the murder had taken place on his property; Thomas Sully was under suspicion because he was spending more money than he had, and the theory was that he had murdered Rossdeitcher and taken his money; and Thornton Adams was arrested because he lived in a room in Jacob's house where some blood was found. All of these suspects could have killed Mox, but which one did the foul deed in Jacob Feitig's barn?

The horse was soon cleared of the crime since he was known as a very gentle horse. Jacob Feitig was arrested in the middle of the night and taken to jail. Treated kindly, he was given beer with his lunch, and his wife brought him some grapes. Being a well-known citizen with considerable wealth, he was quickly bailed out of jail, even though some people had heard Rossdeitcher say that Feitig had struck him. No one seemed to put any credibility in such statements. Thomas Sully seemed to have some

money from an unexplained source, but the money could not be traced to the deceased. In the case of Thornton Adams, the blood in his room, which might have been Rossdeitcher's, made him a suspect. Some people believed that Adams killed Rossdeitcher in his room in Feitig's house and then dragged the body to the barn. Indeed, the county supervisors considered the idea of employing a chemist to check the blood, but this idea was rejected since there was no assurance that the chemist could prove it was Rossdeitcher's blood.

There were still three suspects, but there was no conclusive evidence to link any of them to the crime. While citizens wanted answers, law enforcement authorities were baffled. Although a man had been "brained" in a barn, the guilty party could not be identified. Part of the problem was that a considerable amount of time had passed from the striking of the fatal blow to the start of the investigation, which caused much of the evidence to be lost. There seemed to be no way to explain how the peddler had met his fate. And then a Henrico attorney proposed a very interesting explanation for the murder of Sammox Rossdeitcher.

On September 7, 1890, the Richmond paper reported that a lawyer put forth this theory: "A small hole was found in the roof [of the barn] and there was a strange-looking rock laying near the stall, the likes of which has never been seen on the Feitig farm." The obvious conclusion was that a meteor from outer space had crashed through the roof of the barn and hit Rossdeitcher in the head. The odds against such an event are beyond comprehension, but it seems to have ended the case, and to this day, no one has been convicted of the murder. But the Richmond paper was not content with this explanation and concluded the story with this observation: "There is an old saying about liars and lawyers, and as a consequence, this theory is not accepted." (The old saying is unknown to this writer even though he graduated from the University of Richmond School of Law and has heard a few unkind jokes about lawyers.)

Richmonders can still visit Oakwood Cemetery and see the site of Jacob Feitig's farm, where Rossdeitcher met his untimely death. Maybe as you stand in the cemetery and look at the dark night sky, you might see a meteor racing across the heavens and recall that night in 1890 when a man died in Jacob Feitig's barn. Perhaps if you remain quiet and look toward the cemetery, you can see Rossdeitcher walking among the tombstones with blood gushing from his head and still wondering who, or what, hit him.

Perhaps I should add that I found this story by accident while checking the website Chronicling America. But for this resource, I would never have known that Jacob Feitig, my great-grandfather, had been arrested on a charge of murder. For some unknown reason, no one in my family ever told me this story.

THE RICHMOND CITY AUDITORIUM

Hell is the highest reward that the devil can offer.

—Billy Sunday

Most Richmonders do not know the memories that are held within the cavernous, red brick building with the cupola on its roof and the words "City Auditorium" on its side. Located at Cary and Linden Streets on the spot where Charlie Cox once ran a livery stable, it was opened in 1895 as the West End Farmer's Market, or Third Market, to serve the expanding West End population of the city. This new market contained 140 stalls for the hucksters who sold produce and meat. However, Richmonders

Postcard view of the Richmond City Auditorium. *Special Collection and Archives Virginia Commonwealth University Library.*

continued to shop at the First and Second Markets and did not come to the new market. Since its intended use did not meet expectations, the City of Richmond remodeled the building to serve as a public auditorium.

The building was reopened in 1907 as the City Auditorium, with seating for five thousand people. But the conversion of the farmer's market into a concert hall was not a complete success. A major problem was that the building's temperature was controlled by opening or closing the windows. When the windows were closed, the audience sweltered in the oppressive heat; when the windows were open, the sounds of rumbling streetcars and their clanging bells distracted the audience. On one occasion, Jan Paderewski, the great Polish pianist, stopped his performance to request that the windows be closed to reduce the noise.

One of the first major events held in the City Auditorium was the Confederate Reunion of 1909. Once again, Confederate flags were flown, and aging Confederate warriors were welcomed to the city. The Sons of Confederate Veterans met in the auditorium and expressed the hope that the "memories of the valor and devotion of the Confederate soldiers might inspire the men of the South." Surely the hearts of many pounded as the words of "Dixie" echoed through the auditorium. This reunion was a time of remembering, a time of reflection and a time when those who had screamed the "Rebel yell" on hundreds of battlefields now joined in singing "Auld Lang Syne."

A different kind of music resonated from the building from January 13 to March 2, 1919, when Billy Sunday, the former Chicago White Sox baseball player, led a religious crusade in Richmond. Proclaiming to be "God's recruiting officer," Billy Sunday felt that many people had "just enough religion to make them miserable." Supported by a choir that sang "Carry Me Back to Old Virginny" and more traditional revival music like "Brighten the Corner Where You Are," he sought to knock the devil out of the lives of those who attended his services. In addition to attacking the devil and his fiendish works, Billy Sunday also attacked the sins of the city.

In one sermon, he lambasted politicians by saying that they were "good-for-nothing, godforsaken, rat-hole, tin-horn, weasel-eyed, and peanut-grafting." He also had some comments about overly affectionate young women. He said that any "fool girl who insisted on spooning with every marriageable young fellow of her set ought to be backed into the

woodshed and relieved of her oversupply of affection with a pair of slippers." He also unleashed his picturesque language on "loose women" by referring to them as "painted-faced, manicured-fingered, pencil-eye browed, fudge-eating, gum-chewing, rag-time singing, little frizzle-headed sissies that can't turn a flapjack without splattering the batter all over the kitchen, then they will sit down at the piano and sing, 'Oh, does the spearmint lose its flavor on the bedpost over night.'" Before Billy Sunday left Richmond, he enlisted many soldiers for the "Lord's Army."

In addition to religious crusades, many cultural events were held at the auditorium. Organizations like the Wednesday Club, the Richmond Musician's Club and the *Richmond News Leader* brought many outstanding speakers and performers to the City Auditorium. Well-known speakers included Lady Astor, Herbert Hoover, Charles Lindbergh, William Howard Taft and Woodrow Wilson. Vocalists included Mary Garden, the Scottish soprano; John McCormack, the Irish tenor; and Luisa Tetrazzini, the Metropolitan Opera soprano. Musicians included Sergei Rachmaninoff, the pianist, and violinist Efrem Zimbalist Sr.

Some of these performers left a lasting impression. On one occasion, Metropolitan Opera star Geraldine Farrar had an interpretive dispute with the great Arturo Toscanini. Turning to the maestro, she said, "Remember, the audience pays to see my face, not your backside." A beautiful woman, she performed in Richmond in a sequined strapless gown that was quite a sensation. An account of the concert noted that "the beauteous Farrar was all glittering singer below the waist and all gleaming singer above."

But time was running out for the auditorium as the preferred place for Richmond's public gatherings. On October 28, 1927, a new civic auditorium known as the Mosque (now the Richmond Landmark Theater) opened, and the City Auditorium no longer hosted major cultural events. A reporter reflected on the demise of the auditorium by writing, "Billy Sunday's invitations to the sinners' bench is surrendered to the shriller squeaks of mice…But even now—who knows?—its peeling walls re-echo the faint tinkle of Paderewski's minuets, its grimy ceiling trembles to the remembered thunder of applause welcoming young Richard E. Byrd home from his transatlantic flight."

Although the Mosque was the new place for Richmond's cultural events, the auditorium continued to accommodate smaller gatherings

and high school graduations. The last high school graduation to be held there was the John Marshall High School class of 1933, my mother's class. As the students from "Dear Old John Marshall" pledged to follow their class motto "Keep on keeping on," they did not realize that World War II would soon engulf them.

The auditorium did not close. It became the place for sports enthusiasts to watch boxing and wrestling matches. Fans flocked to the auditorium to see men throw uppercuts, apply chokeholds and scream in anguish like primeval monsters. One wrestler of special note was Eddie Blanks. Although small in statue, he was an excellent wrestler who became a real crowd-pleaser in the Richmond ring.

Since Eddie Blanks's full-time employer was concerned that he might get hurt wrestling, Eddie decided to wrestle in a disguise. Wrestling promoter Bill Lewis made Eddie a mask out of a red stocking cap. To complete the disguise, Eddie recalled, "I bought some red wrestling trunks, wore white socks with red stripes around them, and wrestled under the name of the Red Devil." The Red Devil, along with wrestling icons such as Gorgeous George and Mr. Moto, provided entertainment for many Richmonders.

However, the fans in the City Auditorium were sometimes more dangerous than the opponents in the ring since they would sit in the balcony and shoot the wrestlers with staples propelled by rubber bands. The days of fighting men and flying staples ended in the bleak, early days of World War II, when the auditorium was converted into a garage.

The Richmond paper offered the following obituary for the old building in 1942: "Farewell! Farewell! May the spirit that flamed so often in that ugly, old building survive in beauty elsewhere to the end of days." The interior of the building was ripped out, and it was converted into a repair shop for City of Richmond emergency vehicles. At the end of World War II, the shop was moved, and the building became a City of Richmond warehouse. The city finally decided that the building had "outlived the careers of all and the lives of most, of the star performers who knew it." Referred to as a white elephant, the building was sold in 1960 to Auditorium Associates, which continued to use it as a warehouse. The future of the old building seemed bleak until it was purchased by Virginia Commonwealth University and converted into a gymnasium for its students in the early 1980s.

Now students enjoy the benefits of a modern recreational facility in a building filled with memories of John Philip Sousa conducting "Stars and Stripes Forever," Billy Sunday attacking sin and the Red Devil seeking to twist his opponents into pretzels.

WHITE RIBBONS, TEMPERANCE AND A RICHMOND WATER FOUNTAIN

To quench our thirst we'll always bring
Cold water from the well or spring
So here we pledge our perpetual hate
To all that can intoxicate

These words were part of a rhyming temperance pledge that young people in the nineteenth century pasted in their Bibles to remind them of the need to abstain from alcoholic beverages. Today, these same words serve as a reminder of a time in the nation's history when prohibition was the law of the land and the Woman's Christian Temperance Union led the nation in supporting laws against the illegal consumption of alcohol. Although unknown to many Richmonders, the city has a water fountain in Byrd Park dedicated to the temperance movement and its most articulate spokesperson, Frances E. Willard. The fountain was an appropriate choice for a memorial since, in the days of prohibition, water was promoted as an alternative to alcohol and as a drink that could do everything from "keeping the senses right to making faces bright."

The events for which the fountain was dedicated began in Hillsboro, Ohio, in December 1873 following a speech by Dr. Diocletion Lewis. Dr. Lewis was known for his innovative ideas that ranged from "clean teeth never decay" to the theory that "women with small waists were both delicate and nervous," and he frequently spoke of the evils of alcohol. While in Hillsboro, he added to his planned speeches a free temperance lecture that so caught the imagination of the women in Hillsboro that they marched to the local saloons in an effort to shut them down. The women knelt in the street with their Bibles opened and prayed for divine help to accomplish their mission. Then, while some of the women stayed in the street to pray, others went into the saloons with Bibles in hand and

asked the proprietors to close down their businesses. If they could not convince the owners to close their saloons, they asked the customers to take a no-drink pledge.

The women who marched referred to these activities as "street work" by "praying hands." In time, the prohibition movement flowed from Hillsboro to the rest of the nation, and its leadership was assumed by the Woman's Christian Temperance Union. Frances Willard became the president of the organization and was known as the "Queen of Temperance" until her death in 1898. Eventually, the United States enacted the Eighteenth Amendment, and the United States of America went dry.

The prohibition amendment was already under attack on May 14, 1927, when the Richmond–Henrico County Woman's Christian Temperance Union placed the fountain in Byrd Park to honor both the Hillsboro crusaders who "went out in December of 1873 with the weapons of prayer and faith in God to overthrow the liquor traffic" and Frances Willard as the prime mover in the WCTU. The fountain captured the essence of the cause of temperance with the verse, "The bravest battles that have ever been fought, shall I tell you where and when? On the maps of the world you will find it not; 'Twas fought by the mother of man."

May 14, 1927, the day of the dedication, was not an ordinary Saturday in Byrd Park. It was Play Day, a day when the citizens of Richmond flocked to the park to participate in contests ranging from newspaper throwing by delivery boys to marble shooting. Other events included a fiddlers' contest, a harmonica contest and a play performed by the senior class of Westhampton College. During a lull in the events, the supporters of temperance, each wearing a white ribbon as a sign of their membership in the temperance union, gathered to dedicate the fountain. Mayor J. Fulmer Bright accepted it on behalf of the city and suggested that the "cause of temperance will get stronger in the coming generation because it is God's work to suppress the liquor traffic." He also pledged that the "police force will enforce all provisions of the Eighteenth Amendment, which established Prohibition, to the letter of the law."

Mrs. Howard H. Hogg, the president of the Virginia Woman's Christian Temperance Union, commented that "Virginia makes her bow to Ohio, since Ohio was the mother of the Prohibition Crusade." The chairwoman of the exercises, Mrs. R.E. Thomas, was eloquent when she

Temperance water fountain in Byrd Park. *Photograph by Cara F. Griggs.*

noted that "for the cause of Prohibition, no bloody battles were fought, but the women went to God with prayer to save their homes in the fight for Prohibition." After several other addresses, the water fountain was unveiled. Ironically, a drenching rain ended the ceremonies prematurely. The monument erected for the cause of a dry America promptly got wet!

HOLLYWOOD CEMETERY AND THE BIG BLACK DOG

Life is real! Life is earnest!
And the grave is not its goal;
Dust thou art, to dust returnest,
Was not spoken of the soul.

—*Henry Wadsworth Longfellow*

Hollywood Cemetery in Richmond, Virginia, is a place of memories, a place of reflection, a place of peace and "a bivouac of the dead." In 1847,

Samuel Mordecai described Hollywood Cemetery thus: "The landscape embraces every variety—forest and placid streams, hills covered with woods, or with steeples, shaded valley and blazing furnaces, bridges sixty feet in the air, and almost beneath your feet a broad canal."

Although the blazing furnaces are gone, much of this description is still accurate for Hollywood Cemetery. You can still hear the rushing of the James River, which reminds many visitors of the verse from the Psalms: "There is a river the whereof make glad the City of God." While walking among the monuments in the shapes of crosses, pyramids, angels, columns, doves and little lambs, visitors are moved by the epitaphs like "Rest in Peace," "Lord, I Am Coming," "In God's Care," "Forever with the Lord," "He That Believeth in Me Hath Everlasting Life," "I Give Unto Them Eternal Life and They Shall Never Perish," "Numbered with Thy Saints in Glory Forever" and "Faithful Unto Death." There are even poetic epitaphs like the one carved on the gravestone of a railroad engineer:

His time all full, no wages docked;
His name on God's payroll,
And transportation through to Heaven;
A free pass for his soul.

Named for its many beautiful holly trees, Hollywood Cemetery is the final resting place of presidents, governors, generals, soldiers, judges, clerics and a little girl named Florence Reese.

Presidents James Madison and James Monroe have imposing monuments over their graves. The grave of Jefferson Davis, the only president of the Confederate States of America, is marked by a statue of Davis with a Confederate flag flying in the background. Near the Davis monument is the monument to Confederate general and Virginia governor Fitzhugh Lee. In addition to Governor Lee, five other Virginia governors are buried here, along with more than twenty Confederate generals. Certainly, Hollywood Cemetery is a very special place.

Hollywood also is the final resting place for eighteen thousand Confederate soldiers who died for their young country. One monument bears the inscription, "Fate denied them victory, but gave them immortality." Occasionally, a robin will perch briefly on a long-silent cannon and add color and life to these graves of the valiant.

There are few places like Hollywood where a person can see the final resting places of so many people who made significant contributions to the American nation. But what about Florence Reese? What did she do to be famous? Why do we remember a little girl whose final resting place is Hollywood Cemetery? According to Richmond lore, Florence Reese would walk down Main Street with her father. In front of one of the stores was a big black iron dog, cast in Baltimore, Maryland, and she always patted or hugged it whenever she walked by it. Tragically, Florence contracted scarlet fever and died in February 1862. She was not yet three years of age. Her little body was laid to rest in Hollywood at the same time that many Confederate soldiers were being buried nearby. It was a tragic time for both the Reese family and the Confederate nation. Soon the big black dog that she loved appeared next to her grave.

How did the dog end up near Florence's grave? There are several stories to explain this. One focuses on the war. As the Civil War engulfed Richmond and the South, iron was needed to make instruments of war. Everything that was not essential was being melted down for the war

The big black dog in Hollywood Cemetery. *Photograph by Cara F. Griggs.*

effort. Soon the Richmond authorities started to look at the big iron dog that little Florence so loved. To save the iron dog, it was moved to Hollywood and placed near Florence's grave. Even a desperate nation does not melt down a cemetery monument.

Another story suggests that the dog's owner remembered how much Florence liked to pat the dog, so he kindly gave it to the family to guard her grave. A similar story suggests that Florence's father bought the dog and placed it as a memorial at his little daughter's grave. Regardless of how the dog got there, Florence Reese's grave was now guarded by an iron dog, and the area would be called Black Dog Hill. The big dog that she had loved so much in life now protects her in death. But there is more to the story.

It has been said that the dog will change direction or even walk around the cemetery to protect Florence's grave from harm. There are reports that the dog's footprints can be found on her grave. And the dog's eyes are said to move to keep a watch on visitors to the grave. If you listen carefully on a dark night, you can still hear the dog bark to chase away those who might harm little Florence.

The dog is not the only symbol of affection at Florence's grave. Girls and boys frequently visit her grave and place toys on her headstone and coins on the back of the black dog. Occasionally, a child will place a rose on her grave as a symbol of love for a little girl who died so very long ago and now sleeps for all eternity under the watchful eyes of the dog she loved.

Many things have changed since Florence was laid to rest at Hollywood Cemetery. When she was buried, horse-drawn carriages brought people to Hollywood and Sunday picnics at grave sites were common. Old Confederate soldiers fired their muskets in tribute to their fallen comrades, and orators frequently spoke at the Hollywood Memorial Day programs. As a member of the Thomas Jefferson High School Corps of Cadets, I recall marching to the cemetery on Hollywood's Memorial Day. Across the years, cars have replaced horses, cemetery picnics have fallen out of fashion and the orators have gone silent. But one thing has not changed. The big black dog is always alert, always diligent, always protecting his little friend Florence.

920 WEST FRANKLIN STREET:
A HOUSE OF MEMORIES

My peace I leave with you; My peace I give unto you.
—St. John 14:27, verse over the altar in St. John's Episcopal Church,
where Mary Pegram worshiped

Old houses hold a variety of memories within their walls. Such a house is located at 920 West Franklin Street. Today, it is a house used by Virginia Commonwealth University. Its wide arches have been converted to narrow doors, its large rooms portioned into offices and its many fireplaces rendered inoperative. Still, its former architectural beauty can be seen, and the spirit of its first owner can be felt. If it could be given the power to speak, it would tell a poignant story of a woman named Mary and her special place in the history of Richmond.

Mary Evans Pegram was born in 1832. Her father, James West Pegram, was a general in the Virginia Militia, and her mother, Virginia Johnson Pegram, was the daughter of a successful Virginia horse breeder. When Mary's father became president of the Bank of Virginia, her family moved from Petersburg to Richmond. For the Pegrams, life in Richmond was reflective of their status and style, until the general's death in a steamboat explosion on the Ohio River in 1844. Then, left with limited resources, Mary's family was forced to struggle for survival.

After living in several different places, Mrs. Virginia Johnson Pegram moved her children to 106–108 Franklin Street in Richmond's Linden Row, where she operated a school for young women. While Mrs. Pegram supported her family by teaching school, Mary looked after her younger sister, Virginia, and her three younger brothers: John, James West and William. After her brothers and sister grew up, Mary Pegram taught in her mother's school.

Then the Confederates fired on Fort Sumter, and Mary's life was forever changed. Richmonders celebrated their secession from the Union. From her home in Linden Row, Mary could see the torchlight parades and the Confederate banners flying over Richmond's buildings. Soon, she sadly told her three brothers goodbye as they left Richmond to fight to establish a Southern nation.

While her brothers fought on the far-flung battlefields, Mary continued to help her mother in the school on Franklin Street. Occasionally, she could hear the cannons roar during the battles around Richmond and see the Confederate soldiers marching down Franklin Street. In the winter months, the girls in Mrs. Pegram's school would frequently gather in front of the building and toss snowballs at the passing soldiers. Sometimes, the soldiers fired back with snowballs. These moments of frivolity were rare in wartime Richmond. The Pegrams, like other Richmonders, slowly adjusted to life in a nation that was being bled and strangled out of existence.

Mary's family, it was said, was fortunate. Although the war had killed thousands of young men, the "fighting Pegrams" had survived. Now the war was drawing to its conclusion; additional sacrifices by the men in gray could not save the Confederate nation. At this time, the Pegram family was plunged into grief again. Mary's brother John, a brigadier general, was killed at Hatcher's Run, west of Petersburg, in February 1865. His funeral was conducted exactly three weeks after the day of his wedding to the beautiful Hetty Cary of Baltimore. In April, her brother William fell mortally wounded in front of his cannons at Five Forks, Virginia. This gloom of despair deepened even more when Richmond was burned, when Lee surrendered at Appomattox Court House and when the tattered Confederates straggled down Franklin Street in front of Mary's house. Of the three brothers who had gone off to fight a war, only James West returned home to Richmond when this American tragedy was over.

From her deep faith, Mary Pegram found the strength to endure the tragedy that decimated her family in a cause that was now lost. She continued teaching in schools in Richmond, Baltimore and New York. Then she returned to Richmond in the 1880s and married General James Anderson, a distinguished Richmonder who had managed the Tredegar Iron Works during the war. The general and his bride lived at 113 West Franklin Street. Their home was the center of the Richmond social scene, and one can almost sense the Southern charm of Mrs. Mary Pegram Anderson. Of this home, it was written that it had "been graced by the presence of every stranger of note who had visited the city." Mary's happiness ended in 1892 when her husband died after a marriage of less than ten years. Following his death, Mary Evans Pegram

920 West Franklin Street.
*Photograph by Walter S.
Griggs Jr.*

Anderson sold her home at 113 West Franklin to Lewis Ginter, who later built the Jefferson Hotel on the site.

After leaving the home she had enjoyed with her husband, Mary moved into a house she had built at 920 West Franklin Street in 1894. The house was two and a half stories high and was built on the sidewall plan. It was designed by a young Richmond architect, Benjamin W. Poindexter.

There is no way to know how many times Mary Pegram Anderson might have reflected on the past while living at 920 West Franklin. Perhaps she recalled her father, who was killed while she was still a child. Maybe she remembered those difficult years when her mother struggled to provide for her family. Surely she reflected on the death of her two brothers and the destruction of the Old South. Certainly she wondered why when she had finally found happiness in marriage, it fell far too short. Yet Mary Pegram Anderson was a proud woman who did not

bend under adversity. Socially, she was described "as a sensitive southern woman, [of]…fine intellect, wit, dignity, and grace."

One author recalled, "Slight in stature, but very erect, and possessing unusual distinction of manner and speech, no one, who ever saw this dear lady of the old regime in her own home, or walking or driving in the streets of Richmond, or passing down the middle aisle of St. Paul's Church to her pew there, could ever forget her appearance and striking personality." She found solace in her church, which became the sustaining focus of her life. In this historic church, she placed two memorials: a stained-glass window to honor her parents and a mosaic of Da Vinci's *The Last Supper* to honor her husband.

Mary Pegram Anderson died in her home at 920 West Franklin on December 26, 1911. Her funeral was conducted from the house, and her body was carried down Franklin Street to Hollywood Cemetery. Here the earthly remains of Mary Pegram Anderson were laid to rest. On her tombstone were inscribed the words, "Blessed are they which do hunger and thirst after righteousness, for they shall be filled." The faithful of St. Paul's Church are still reminded today of Mary Anderson, for on the communion table is a plaque inscribed, "In Loving Memory of Mary E. Pegram Anderson."

CHRISTOPHER COLUMBUS: ADMIRAL OF THE OCEAN SEA

You can never cross the ocean unless you have the courage to lose sight of the shore.

—Christopher Columbus

On August 3, 1492, Christopher Columbus attended Mass at St. George's Church in Palos, Spain. Then, "in the name of Jesus," he ordered his three ships, the *Niña*, the *Pinta* and the *Santa Maria*, to set sail in search of the Indies. For several months, these ships sailed where few had sailed before. Day after day, the sailors followed a routine that included Columbus searching for the North Star, all hands singing the words, "Salve, Regina, Mater misericordiae, vita, dulcedo, et spes nostra, salve" and lookouts peering across the seemingly endless sea

looking for land birds, floating vegetation and any evidence of land. And then it happened! Rodrigo de Triana, a lookout on the *Pinta*, screamed, "Tierra! Tierra!" A New World had been found by the Europeans.

Columbus and his sailors did not know it at the time, but they had found a new continent that in time would be called "America." Columbus had shown courage and determination in the face of the challenges of the unknown, the threats of mutiny and the perils of the restless sea. This voyage of Columbus's remained a source of national pride for many Italians, including a Richmond barber who decided that Richmond needed a statue of Christopher Columbus.

The crusade to remember Columbus was started by Frank Realmuto, an Italian American barber who worked at the Central YMCA. Mr. Frank, as he was known, came to America in 1896 and was very proud of the fact that Christopher Columbus, a fellow Italian, had discovered his new homeland. Mr. Frank obtained the support of the Italian American Society in the early 1920s and began to raise the money to build a Columbus statue in Richmond. Since this statue was to honor an Italian, funds were accepted only from those of Italian ancestry.

In keeping with the goal to make the statue an all-Italian project, Ferruccio Legnaioli, an Italian by birth living in Richmond, was commissioned to create the statue. Although Mr. Frank and his fellow Italian Americans were enthusiastic in their efforts to remember the famous admiral of the sea, their enthusiasm was not shared by everyone in Richmond, most notably the Ku Klux Klan. The Klan and its minions argued that Columbus did not deserve a statue since he was a foreigner and a Roman Catholic—and because he did not *discover* America at all. The fate of the statue seemed at one point to be sealed by the Klan lobby when a committee of the Richmond city governing body rejected the gift of the statue. Following the vote, the "Rebel yell" was sounded in the chamber. Fortunately, reason prevailed over prejudice. The vote was overridden, and the City of Richmond accepted the statue and authorized it to be placed in Richmond's Byrd Park at the south end of the Boulevard.

The dedication was planned for Columbus Day, October 12, 1927. Unfortunately, the Italian ambassador could not come to Richmond on the planned day, so the statue was not dedicated until December 9, 1927. On the day of the dedication, the *Richmond Times-Dispatch* noted that

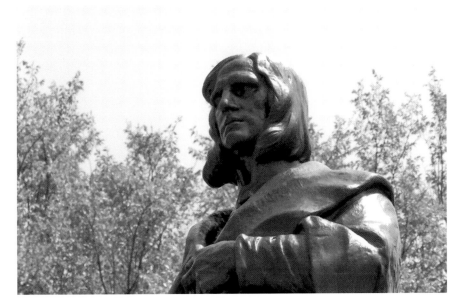

The Christopher Columbus Monument in Byrd Park. *Photograph by Walter S. Griggs Jr.*

no citizens were "more law-abiding, more patriotic, more industrious, more jealous of those virtues which characterized the great Romans of another day, [than those Italians] who have elected to live in our midst and embrace American citizenship."

The day of the dedication was a cold, bleak, windy day in Richmond, but more than one thousand spectators attended the dedication. The United States Marine Corps Band was present along with the corps of cadets from Richmond's Benedictine High School and John Marshall High School. Following a prayer by the Right Reverend Andrew J. Brennan, the bishop of Richmond, Mr. Frank addressed the crowd. He said that the monument would remain "a perpetual honor to the memory of the intrepid seaman who sacrificed his all to give us this great nation." He also reminded the audience that the "statue was carved by the hands of an Italian, erected by Italians, and subscribed entirely by Italian citizens." Then Governor Harry F. Byrd welcomed Nobile Giacomeo de Martino, the Italian ambassador, by saying that "we Virginians regard Mussolini as one of the few great, supreme leaders the world has produced." He referred to Mussolini as "a man called of God." The ambassador then commented that "my chief, Mussolini, has charged me in bringing a

message to Governor Byrd to express his appreciation for the monument in this city and for the sympathy expressed for the Fascists."

Following the orations, the Italian and United States flags, which had covered the monument, were removed, and the statue was unveiled—a statue showing a bronze Columbus with a pageboy haircut and wearing a long robe, with one hand resting on some books and the other hand holding a scroll of maps. Mayor J. Fulmer Bright accepted the monument on behalf of the City of Richmond. The Columbus statue was the first monument to be illuminated at night in Richmond and the first monument of Columbus shown standing in the entire South.

The next day, there was a brief reference in the Richmond paper to a small, black Fascist flag flying on the ambassador's car—a small flag that would in a few years become a large symbol of infamy. But the monument was not yet complete. In 1938, a fountain of cascading water was placed behind it. Designed to blend with the statue, the flowing water gives the statue life, and it serves as a reminder of the sea that Columbus crossed. It forms a fitting backdrop to the monument.

Although opinions about Christopher Columbus have changed across the years, he remains one of the world's greatest explorers. He opened the New World for citizens around the world. It was Columbus who said, "And the sea will grant each man New Hope." Even today, those who cross the Atlantic still find a new hope in the New World.

CANNON MEMORIAL CHAPEL AT THE UNIVERSITY OF RICHMOND

Verbum Vitae et Lumen Scientiae
—"Word of Life and the Light of Knowledge,"
University of Richmond motto

In my world, the University of Richmond occupies a very special place. I cannot walk across the campus without it opening floodgates of memories that recall a time when I was a bewildered college student full of hopes and dreams.

I can look at Boatwright Library and remember the days I spent reading book after book trying to complete my degree in history. I can

pass Ryland Hall and recall the day one of my classmates brought a duck to class or when Dr. Spencer D. Albright asked me to make a speech on behalf of the Prohibitionist Party. And I can still recall the night I drove to campus around midnight to check on a grade. I got out of my Corvair with flashlight in hand and timidly headed toward the biology building in an effort to find my grade. Finding the door, I turned my flashlight on the grade sheet. And there it was in all of its glory: "W S GRIGGS—D." I recall falling to my knees and thanking the Almighty that I would never have to cut up another frog. My mind is somewhat foggy on this, but I think I recall hearing a chorus of frogs in Westhampton Lake croaking the "Hallelujah Chorus."

But the University of Richmond is more than buildings, books, frogs and grades. I met and married a woman named Frances Pitchford who walked the long, cold path from Westhampton College, the Women's Division of the University of Richmond, to the bus stop almost a mile away. Frances is responsible for many of my memories of the University of Richmond, especially memories of Cannon Memorial Chapel. One day, Frances and I agreed to meet at the back of the chapel following a mandatory convocation. But there was a problem! She believed that the back of the chapel was the area behind the building, and she went there to wait. I believed that the back was the place where people entered the building (at the back of the sanctuary), and I waited there. We never found each other that day. Every time I see Cannon Chapel, it reminds me of that missed meeting and how that misunderstanding almost ended a beautiful relationship with a Westhampton woman.

When Frances and I were playing "ring around the chapel," we did not know the history of this building. The chapel was made possible by a gift of $125,000 from Mrs. Lottie Southerland Cannon. It was erected in memory of her husband and named the Henry Mansfield Cannon Memorial Chapel. Mrs. Cannon said of her gift, "I finally decided for myself that the University of Richmond would be here as long as the city itself and that I should place my memorial on the University campus."

The chapel for the University of Richmond was designed as a collegiate Gothic structure. Collegiate Gothic was supposed to suggest "eternal values" and "exalted ideals of education and religion." Built on land not far from the site of a Civil War battle, the chapel overlooked Westhampton Lake. When construction began, World War I was still on

Cannon Chapel at the University of Richmond. *Photograph by Cara F. Griggs.*

the minds of the students, who described the noise from the construction site as reminiscent of the artillery fire at the Battle of the Marne.

Cannon Chapel was dedicated in 1929 following an address by Dr. Clarence A. Barbour, the president of Brown University. Dr. Barbour suggested that religion was able to solve many of the problems of modern life. With the singing of "The Church's One Foundation," the chapel became a place of reflection and worship for the university community.

At the time the chapel was dedicated, freshmen were known as "rats," and a "rat" was defined as "an incorrigible reformatory timber in dire need of reformation and an iconoclastic invader of the domain and freedom of upperclassmen." Surely, the Richmond "rats" found some much-needed peace and even "amazing grace" while attending chapel services.

Across the years, the chapel walls have been silent witnesses to the many prayers offered by members of the university community. It has also been the place where many sermons and speeches have been delivered, as well as a place where choirs sang, vespers were held and campus

traditions, such as the Westhampton College Proclamation Night, have been maintained. And since chapel attendance was required in the early days of the university, there was always a captive audience.

In 1931, a speaker told Westhampton students that they needed to attend camp in the summer so that "women could be exposed to the warm sunlight and dashing rain while listening to the music of the wind." In that same vein, Westhampton women were told to become missionaries for a year so that their boyfriends would miss them.

Fred Waring, a popular band leader, introduced a new UR fight song in a chapel concert in 1940. One stanza of this "masterpiece" contains these words:

> *Yes, the Spiders are on a spree!*
> *We'll chase 'em up a tree!*
> *We'll beat them, yes-siree!*
> *We'll fight for victory!*

When the song ended, the Gothic arches of the chapel echoed with the screaming approval of all of those who were "spider-born and spider-bred."

Although the students did not know it at the time, within a year many of the screaming students would be engaged in a desperate fight for victory during World War II. During the days of the war, bond drives were held in the chapel. Faculty, staff and students standing on the roof of the chemistry building watching for German aircraft could easily see the chapel. Surely they prayed that the end of the war might come soon and spare their loved ones. Following the war, one of the most memorable programs occurred in 1946 when World War II leaders Admiral Chester Nimitz and General Dwight D. Eisenhower were awarded honorary degrees in a chapel ceremony. General Eisenhower said, "There was not one man to come back from France who wanted to see his son have to go through another war."

In the 1960s, I attended many mandatory chapel programs, none of which can I remember, except for a comment from Dr. George M. Modlin, the president of the University of Richmond, who cautioned about speeding cars and told some awful joke about men not wearing shirts of the "T" model on campus. When Dr. Modlin died, his funeral

was held in the chapel. As his casket was carried from the building, the strains of "When the Saints Go Marching In" were heard across campus.

The chapel has often been a place of funerals and weddings, but it has also been the place for many campus programs. Senator Strom Thurmond made the following comment during a chapel address: "It amazes me that professors are not well-informed. Many students are better informed than their teachers." On a much more caring note, Reverend Dr. David D. Burhans, the university chaplain for more than thirty years, used the words of St. Paul to caution students that "you should not be conformed to this world but be transformed by the renewal of your mind, that you may prove what is the good and acceptable will of God." These words remind students of the need to keep their hearts and minds focused on the will of God while living in a world filled with incomprehensible challenges and changes.

Students faced a major challenge to their world on September 11, 2001. Following the day when the United States was attacked, Cannon Memorial Chapel was filled to capacity when the ancient words of the Twenty-third Psalm were repeated. Surely the students reflected on the lines "Yea though I walk through the valley of the shadow of death."

But Cannon Chapel has been more than a place of prayer; it has also been the venue for such unspiritual pursuits as card games, knitting, gossiping and love letter writing. Such events have frequently occurred during mandatory convocations. These activities were termed "barbarous behavior" by a concerned student.

Generations of students have come and gone since Cannon Memorial Chapel first opened its doors. It has undergone renovations, and a magnificent organ was installed in it. Yet in many ways, its walls remain the same. These walls will always hold in sacred trust the thoughts of students who have met the challenges of life by sitting in the pews of the chapel and reflecting on the academic discipline of "Westhampton, Wondrous Mother True" or the memories of "Dear Old Red and Blue."

The first students who went into the chapel in the 1920s carried textbooks and book bags. Today, students have laptops and iPods. Richmond students no longer have to memorize the definition of a "rat," but they still have to learn something about zoology and other academic disciplines. Perhaps when a student leaves the chapel, he or she might hear the quacking of a campus duck or the croaking of a frog whose ancestor was left to croak again by the D that I received in zoology.

Part III

WORLD WAR II

DEATH IN THE SOUTH PACIFIC

Eternal Father, Strong to save,
Whose arm hath bound the restless wave,
Who bid'st the mighty Ocean deep
Its own appointed limits keep;
O hear us when we cry to thee,
for those in peril on the sea.

—U.S. Navy hymn

My mother rarely spoke of World War II, but whenever she mentioned it, she would always comment that Johnny Wingfield was killed in the war. She said nothing more. After my mother's death, I found her John Marshall High School Annual, the *Marshallite*, for the class of 1933. When I looked in the annual, I found a picture of John Davis Wingfield, and under his picture was signed "Johnny." I also learned from the annual that he was a leader in the senior class and wrote the class history, which he closed with the class motto "Keep on keeping on."

Following graduation from John Marshall, Johnny Wingfield attended the University of Virginia and graduated in 1938 with a Bachelor of Science degree as a dean's list student. He was involved in many extracurricular activities as diverse as being on the boxing team and being a member of the Virginia Players. Upon graduation from

Virginia, he started his career working at the DuPont Plant at Ampthill in Chesterfield County, Virginia, but war clouds were gathering on the horizon and getting darker and darker. Realizing that war might soon engulf the United States, he made a decision that changed his life. He joined the United States Navy.

On November 15, 1940, he was appointed an aviation cadet with the rank of ensign. Following training at Jacksonville and Miami in Florida, as well as Anacostia Field in Washington, D.C., he was ordered to San Diego, California, for additional training with the Advanced Carrier Training Group, Pacific. After Pearl Harbor was attacked, he reported for duty with Scouting Squadron 2 on December 28, 1941. This squadron was assigned to the aircraft carrier USS *Lexington* (CV2).

The *Lexington* saw initial action in the South Pacific before returning to Pearl Harbor on March 26, 1942. After a brief stay, the ship departed Pearl Harbor, and its air groups flew out from Pearl Harbor to join it. The planes landed on its deck without incidence, including the plane piloted by Ensign Wingfield. With its aircraft and pilots safely on board, the mighty aircraft carrier sailed toward Australia and into the Coral Sea, where it encountered the Japanese navy in what became known as the Battle of the Coral Sea.

On May 7, 1942, the two fleets engaged in the first naval battle in history in which the combatants never saw each other's ships. They used their aircraft to try to bomb each other out of existence, instead of a classical engagement between ships firing at each other. On May 8, 1942, Wingfield was piloting his Dauntless Douglas Dive Bomber (SBD) in an attack on the massive Japanese aircraft carrier IJN *Shaokaku* ("Floating Crane" or "Flying Crane"). Wingfield hoped to sink this aircraft carrier that had participated in the Japanese attack on Pearl Harbor. He made his bomb run on the carrier, but for some reason, the bomb did not release. Unaware of the situation, Wingfield was headed back to the *Lexington* when he was told he still had the bomb. Instead of continuing to follow his course to the USS *Lexington*, he turned back to attack the Japanese carrier.

His lone plane was fired at by Japanese aircraft and shipboard guns. He was never seen again. His fate remains unknown. Why did he risk almost certain death by flying alone to attack the carrier flying the flag of the imperial Japanese navy? Given his courageous act, he obliviously put love of country before love of self. What were his final thoughts as his

plane was being torn apart by Japanese bullets? Were they of "Dear Old John Marshall," the University of Virginia, his mother or his family, or maybe it was his class motto "Keep on keeping on"? We will never know. Nor did Johnny Wingfield ever know that his courageous actions earned him the Navy Cross. Naval historians describe the Japanese as the tactical winners of the battle, but the real winner was the United States Navy.

Mrs. Wingfield soon received the dreaded telegram that her son was missing in action, and in late 1942, she was presented the Navy Cross earned by her son on the day before what would have been his twenty-fifth birthday. Mrs. Wingfield was requested to hold the award pending the return of her son or further information was received about him. In the citation accompanying the medal it was stated: "Ensign Wingfield's courage, daring airmanship, and devotion to duty were in keeping with the highest traditions of the United States Naval Service. He gallantly gave his life for his country."

But a grateful nation had not finished honoring this young man from Richmond who died in a courageous attempt to sink a Japanese aircraft carrier. Mrs. Wingfield was advised that a navy destroyer escort was going to be named in honor of her son and that she was to be the sponsor.

On December 30, 1943, Mrs. Wingfield smashed a bottle of champagne on the bow of the ship at a shipyard in Newark, New Jersey, while saying, "In the name of the United States, I christen the *Wingfield*." The Richmond papers reported that the *Wingfield* slipped down the ways into the water and joined the fleet. Following the christening, Mrs. Wingfield returned to her home with a gold star in the window in memory of her son.

The ship was commissioned in January 1944. The first entry in the deck log is as follows: "Set the first watch. Commissioning ceremonies completed, Rear Admiral Kelly left the ship, Captain left the ship at 1415-1430." The USS *Wingfield* (DE 194) was now to be prepared for combat.

The *Wingfield* served in both the Atlantic and Pacific. Following the Japanese surrender, it was the first United States Navy ship to enter the Maloelap Atoll, where it proceeded to Toroa Anchorage. There Admiral Tamada of the imperial Japanese navy signed a surrender agreement, while the *Wingfield*'s sailors stood at attention in dress white uniforms. The ship fired a twenty-one-gun salute when the United States flag reached the top of the flagpole. Ensign Wingfield would have been proud.

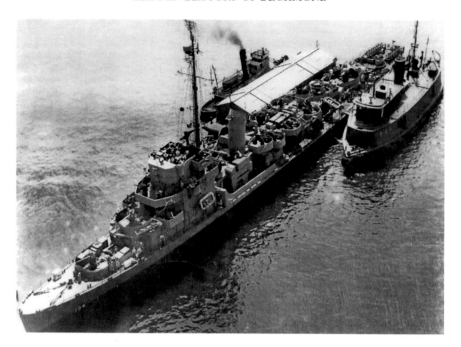

USS *Wingfield* during World War II. *Courtesy of the U.S. Navy.*

Although he died at the start of the war, a ship bearing his name witnessed the lowering of the Japanese flag and the raising of the flag of the United States of America at the end of the war. Ensign Wingfield was one of many servicemen who died in World War II, but he surely lived up to the motto of his class at John Marshall High School.

RICHMOND PIGEONS: FAST-FLYING, FEATHERED FREEDOM FIGHTERS

The pigeon is a beautiful bird, of a delicate bronze colour, tinged with pink about the neck, and the wings marked with green and purple.
—William John Willis

Richmond, Virginia, has been described in many ways. Some suggest that it is our nation's most historic city. Others view it as a city of churches or a city of monuments. But it can also be viewed as a city of pigeons. From perching on the head of Washington's statue in Capitol Square

to buzzing the monument of Jefferson Davis on Monument Avenue, Richmond is blessed with many pigeons. Many of the city's visitors see and feed the pigeons, but few of them are aware that because of the bird's ability to carry messages, pigeons have earned an important place in our nation's history.

Indeed, it was a pigeon in the service of the Roman army that brought back the news of the conquest of Gaul to Rome, and it was a British pigeon that winged back to England with the news of Napoleon's defeat of Waterloo. American pigeons have added luster to these earlier exploits. When the United States entered World War I, pigeons went "over there" to serve as messengers. Two of these pigeons are still remembered for their heroism in that war. A pigeon named Cher Ami lost an eye and a leg but managed to deliver a message that helped to save the famed "Lost Battalion." This exploit was matched on November 5, 1918, when a pigeon named President Wilson flew through fog and shrapnel to carry an urgent message to his roost in Cuisy, France, that saved many lives. This gallant bird lost a leg during the war but earned the gratitude of a grateful nation.

On December 7, 1941, Pearl Harbor was attacked, and the army once again turned to the faithful pigeons. When the need to raise more pigeons arose, the pigeon fanciers from Richmond played a major role. The Richmond pigeon community donated some two hundred of its best pigeons to serve the war effort. One pigeon breeder explained that despite the development of modern communication methods, pigeons still played an important role in military maneuvers because they could get through when other means of communication failed. When the pigeons shipped out, the Richmond paper in March 1942 reported, "Heeding a nation-wide call from the Signal Corps for topnotch birds capable of producing tough and battle worthy young, Richmond pigeon fanciers reached into their lofts for some of their best homing pigeons and shipped them to Washington, D.C." The article continued by reporting that one of the pigeon fanciers said that "Uncle Sam can do what he wants with them, but we hope they will raise some young ones who will save our boys lives."

Richmond pigeons, as well as patriotic pigeons from across the nation, were willing to lay eggs and fly for freedom, but they still had their detractors. One wit claimed that pigeons were being crossbred with parrots so they could speak their messages, and another joke suggested

Heroic pigeon at Parade Rest. *Photograph by Walter S. Griggs Jr.*

that pigeons were being crossed with Western Union boys so they could sing and salute when they reached headquarters. In spite of these cruel comments, the pigeons distinguished themselves during World War II in a variety of missions in different theaters of the global war. A pigeon from the North African Platoon named Yank (the name suggests that this was not a Richmond pigeon) was credited with carrying the news of the retaking of Gafsa during the Tunisia Campaign. Yank flew ninety miles in 110 minutes with this vital information.

In the Italian Campaign, pigeons from the 209th Signal Pigeon Company were sewed into the coats of Italian partisans, who released them with the critical messages concerning German troop movements and gun emplacements. During the Italian Campaign, a courageous pigeon named Liles Boy flew forty-six combat missions.

Pigeons were also with the Allies when they invaded Normandy on D-Day. These pigeons were used to carry exposed film from the combat photographers on the front lines back to headquarters for processing, thus giving the Allies needed information about the progress of the

invasion. But the use of pigeons was not limited to the army; the navy also used them. Navy supply ships at Okinawa carried pigeons, and when the ships approached the harbor, a message describing the ship's cargo was attached to a pigeon. Perhaps with the shout of "Pigeons away!" the pigeons were released and carried the message to shore, where it was read by the beach master, who could then determine a proper time and place to dock the ship.

Today, pigeons are no longer flying missions for our nation's armed forces, and most Richmonders have forgotten the role that the valiant two hundred played during the darkest days of World War II. Pigeons, however, have not faded away like old soldiers. They perch on many of Richmond's buildings, poised to fly into action if their nation should call. Although Richmond has not honored these messengers of freedom with a monument of their own, most of Richmond's monuments have been honored by a visit from one of Richmond's pigeons. And I must confess that whenever I see a pigeon, I kneel down and thank the pigeon for what his ancestors sacrificed to make America the "land of the free and the home of the brave." When people see me do this, they give me a funny look. Perhaps this story will help them to understand why I pay homage to our feathered freedom fighters.

THE USS *RICHMOND* (CL-9)

We have just begun to fight.

—John Paul Jones

In September 1921, a special train left Richmond for Philadelphia carrying a young lady with a unique assignment. Miss Elizabeth Strother Scott had been selected to christen a navy cruiser named for Richmond, Virginia. On September 29, 1921, Miss Scott, in the presence of Richmond mayor George Ainsile and a host of other Richmonders, christened the USS *Richmond* at Camps' Shipyard in Philadelphia. (The cruiser was probably christened with apple cider since champagne had fallen victim to prohibition.)

The United States Navy's newest cruiser had twelve six-inch guns in its main battery and numerous smaller guns in its secondary battery.

The USS *Richmond. Courtesy of the U.S. Navy.*

It also carried torpedoes, mines, airplanes and a mascot, an Airedale terrier presented to the ship by Dr. W.S. Budd of Richmond, Virginia. Designed to serve as a scouting vessel, a minelayer and an airplane carrier, the *Richmond's* length matched the Washington Monument's height and could cruise in excess of thirty-three knots. Newspapers in Richmond expressed regret that the *Richmond* was too large to sail to its namesake city, but they indicated satisfaction that its first commanding officer was a southerner from Alabama. After it was commissioned in 1923, the *Richmond* had numerous naval assignments associated with a peacetime navy, including fleet training exercises, rescue missions and escort duty.

The cruiser was steaming for Valparaiso, Chile, when its crew received news of the Japanese attack on Pearl Harbor. Immediately, it altered course to take a position guarding the Panama Canal. In subsequent deployments, the *Richmond* escorted convoys, sailed on numerous defensive patrols and engaged in anti-shipping sweeps. During the course of the war, many changes were made to the *Richmond's* weaponry to prepare it for various missions.

The USS *Richmond*'s most famous action occurred on March 26, 1943, in what was known as the Battle of the Komandorski Islands. In the frigid waters of the North Pacific, the battle developed when the Japanese tried to escort a convoy through the American blockade to reinforce some Japanese-held islands. The cruiser served as the flagship in this three-and-a-half-hour naval battle. Although outnumbered two to one, the American forces engaged the Japanese ships. The Japanese first concentrated their fire on the *Richmond* but soon shifted their guns to the cruiser *Salt Lake City*. When this ship was stopped dead in the water, *Richmond* came to its aid. With sailors at their battle stations and the captain on the bridge, the cruiser's six-inch guns fired at the enemy ships. The Japanese commander broke off the action and left the area. Their efforts to break the blockade had failed. An officer on the *Salt Lake City* reflected on the battle and commented, "This day the hand of Divine Providence lay over the ships. Never before has death lay so close for so long." The USS *Richmond* had witnessed its finest hour.

Until the war ended, the *Richmond* continued to serve with distinction in the North Pacific. It was off the coast of Japan when the Japanese surrendered. A news story dispatched from Richmond reported that "the *Richmond* has endured the poundings of the bleak and turbulent North Pacific almost constantly for two years, setting a record unmatched by any other ship in the navy." The cruiser's combat record at war's end included participating in two invasions, twelve shore bombardments and three surface actions. Its service to the nation earned it two battle stars, but it would have little time to wear them. Within six months from the fall of Japan, the *Richmond* was decommissioned, struck from the list of naval ships and sold for scrap. Appropriately, the same lady who christened the *Richmond* was at the ceremony when the bell was returned to the city whose name the ship so proudly bore.

The city's name was carried across the oceans of the world by USS *Richmond* for almost twenty-five years. Perhaps at some future date, another ship will be named for Virginia's capital, and the Stars and Stripes will once again unfurl from the gaff of a ship with this proud city's name.

Part IV

TRANSPORTATION

THE LAST KISS: THE COLLAPSE OF THE CHURCH HILL TUNNEL

It was October 2 of 25.
A gray day, wet and cold.
Tom Mason fired up the old steam train
Engine 231 we're told.

Sixty feet under 24th Street,
Stopped the work train with her crew.
Having dropped the cars, Tom started on.
At that instant fell a brick or two.

"Watch out! Tom, she's a comin' in,"
Fireman Mosby cried.
And, boy, she did that fateful day
Burying the train and its crew along the way.

−Bob Harrison

A train is buried under the city of Richmond. A locomotive, its coal tender and a string of freight cars have been buried under the city since October 2, 1925, when the Church Hill Tunnel collapsed on it. Although this railroad disaster has never achieved the notoriety of the "Wreck of

Old 97" or the collision that killed Casey Jones, it is a railroad story that has always fascinated Richmonders.

The story began on February 1, 1872, when construction was begun on the Church Hill Tunnel. The tunnel was designed to connect the Chesapeake & Ohio Railroad tracks in Shockoe Valley to the docks on the James River at Rocketts Landing. Although there were experts who felt that it was a mistake to construct a tunnel through the unstable ground under Church Hill, the engineers and the C&O felt that the tunnel was feasible.

During the course of the construction, there were numerous cave-ins resulting in several deaths and serious injuries, but the work continued. The tunnel was finally completed, and on December 11, 1873, a locomotive named the David Anderson steamed through it. One of the longest tunnels in the United States was now in service. Unfortunately, the shallow James River prevented large oceangoing vessels from coming to Richmond, and the City of Richmond did not deepen the channel

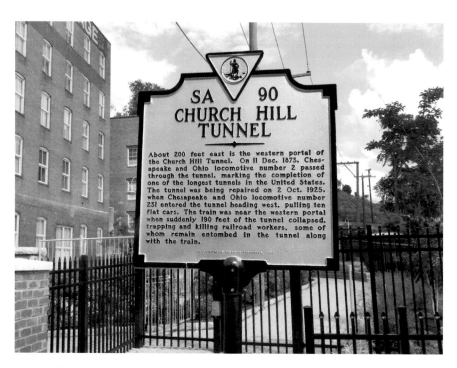

Church Hill Tunnel sign at the Tunnel's Western Portal. *Photograph Cara F. Griggs.*

as it had promised. With the Port of Richmond inadequate, the C&O extended its tracks to reach the deep-water port at Newport News. With access to a deep-water port, the Church Hill Tunnel was used less and less frequently. In 1902, the last scheduled train passed through the tunnel. The tunnel was found unsafe for further use in 1915, and for the next ten years, it remained closed. However, by 1925, rail traffic had increased, and the C&O began repairing the tunnel so that it could be restored to service.

Work was progressing in the tunnel when disaster struck. Around 3:00 p.m. on October 2, 1925, engineer Tom Mason left his home and walked to the corner of the block. For some reason, he turned around, went back to his house and kissed his wife again. Then he headed to Fulton Yard, climbed aboard locomotive no. 231, released the brakes, opened the throttle and began to pull a string of ten flatcars into the Church Hill Tunnel so that the laborers could load them with dirt and construction debris. When Mason's locomotive reached the area under Twentieth Street at Jefferson Park, a few bricks in the tunnel's roof fell with a splash into pools of water on the tunnel floor. The falling bricks caused the electrical connections to break, and the tunnel was thrown into darkness. Carpenters working at the eastern portal of the tunnel near Chimborazo Park, about a mile from the cave-in, felt a sharp swish of air, and they immediately left the tunnel and ran into the rain falling outside. As the workers were running out of the tunnel, 190 feet of the 4,000-foot tunnel collapsed under Jefferson Park.

B.F. Mosby, the fireman on the doomed locomotive, yelled, "Watch out, Tom, she's a-coming in." Seconds later, Mosby and Mason were scalded by steam escaping from the crushed locomotive. In spite of severe burns, Mosby slipped out of the locomotive's cab, crawled under the flatcars behind the train and escaped from the collapsing tunnel. When he emerged, he told bystanders to tell his wife and little girl that he was all right. He died the next day.

Engineer Mason was a large man and, unlike Mosby, could not slide out of the locomotive's cab. R.C. Gary, a foreman, was at work on the eastern end of the tunnel when he felt the sharp swish of air as the mass of dirt fell in. Running to the train, he made a desperate effort to get Mason out, but the engineer was pinned by debris and by the reverse lever that was lodged firmly across his chest. A.S. Adams, the flagman on

the doomed train, was standing on a flatcar when the first bricks began to fall. He was able to dive under the car and crawl out of the tunnel. Charles Kelso was also in the tunnel when it collapsed and escaped by crawling to safety using the flatcars as an escape tunnel within the collapsed tunnel. Cut on the head, he was sent home in a cab by the C&O. He never talked about his close encounter with death. Harold Glenn and his father, John B. Glenn, were both working in the tunnel at the time of the cave-in. Fortunately, they heard the noise of the collapsing tunnel and were able to escape. Harold Glenn immediately called his fifteen-year-old girlfriend, Annie L. Walters, to let her know that he was not hurt.

Falling clay, collapsing supports, splitting wood, screaming men and escaping steam from the dying locomotive echoed throughout the dark, damp tunnel. Survivors recalled the eerie screams of the maddened men rushing through the blackness to either safety or death. A carpenter gave the following account of the disaster:

> *Men passed me screaming and fighting. Some of them yelled that they had knives and would cut anybody that got in their way. The confusion lasted for a long time it seems. There were no lights. Men ran back and forth bewildered. Some of them ran toward the cave-in. Others butted their heads into the sidewalls, fell over the ties and rails and knocked each other down. We were without knowing what had happened or what was going to happen.*

At the cave-in site, rumors were rampant. There were many reports of people hearing noises inside the tunnel. Richmonders kept up hope that Mason and the other trapped men might still be alive. The *Richmond Times-Dispatch* reported, "Tom Mason might be at his throttle, his burned body supported by the loose clay which had poured in under the roof of the cab." Also missing were two African American laborers: Richard Lewis and H. Smith. But were there more laborers in the tunnel? One story that emerged was that workers in the tunnel had been issued work boots that were to be returned to the roundhouse at the end of the day. Many of these boots were never returned. Were they on the feet of men trapped in the tunnel? It is also possible that people came from the Deep South seeking a job. They might have gone into the tunnel to find a foreman when the tunnel caved in on them—perhaps they were never found and

were not missed by their families since they were not expected to return to their homes. It will probably always be a mystery as to the number of men whose final resting place is within the Church Hill Tunnel.

People flocked to the site of the cave-in. A favorite viewing site was the viaduct that connected Church Hill to downtown Richmond. Charles Williams recalled standing on the viaduct watching the rescue efforts with his father and two brothers. He recalled that the crowd was milling around waiting for news of the rescue effort. At a time of racial segregation in Richmond, blacks and whites stood together sharing a common hope and a fervent prayer that some men might still be found alive in the tunnel.

At first, a large steam shovel was used to cut into Jefferson Park in an effort to rescue those trapped in the tunnel. Unfortunately, the powerful steam shovel caused additional cave-ins. With the steam shovel out of use, the C&O was forced to try another approach. Consequently, the railroad started digging shafts from the surface of Jefferson Park in an effort to reach the trapped train below. This method seemed slow, and Richmonders were critical of the time it was taking to reach the trapped train. To reduce public criticism, the C&O issued daily reports letting people know that every effort was being made to reach the train as quickly as possible.

Finally, on October 11, 1925, nine days after the cave-in, workers cut through a flatcar and crawled up to the engine. There they saw the body of the engineer. With the aid of an acetylene torch to cut through the reverse lever that pinned him to the seat, the dead engineer was freed. And at the top of the hill, Tom Mason's little boy, who had hoped and prayed that his daddy would be found alive, could now end his lonely vigil. Harold Glenn went back into the shaft from which Tom Mason had been removed and retrieved the engineer's lantern. He put the lantern down and continued to work. While he was working, someone took the lantern, and it was never recovered.

Ironically, Tom Mason's funeral was held at St. Patrick's Church, and Ben Mosby's was conducted at St. John's Church. Both of these churches were within a few yards of the tunnel that had claimed the lives of both of these men.

For many days, the men of the C&O searched in vain for Richard Lewis and H. Smith and any other men who might have been buried in the tunnel. But no more bodies were ever found. Realizing that

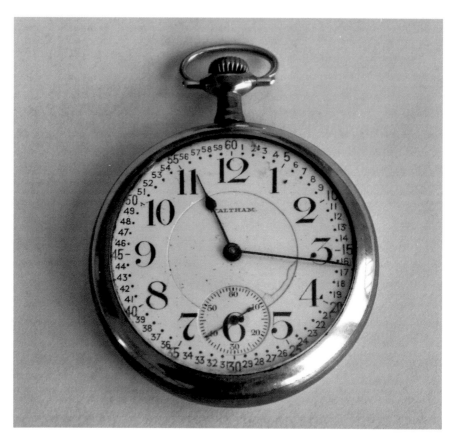

Tom Mason's railroad watch. *Courtesy of Gary Mason (grandson) and Ashleigh Mason (great-granddaughter).*

further searching would be futile, the C&O began to contemplate the future of the tunnel. Since only a small section had collapsed, it could have been repaired and put back into service. However, the tunnel had been a source of constant trouble and was not essential to the railroad's operation, so the C&O decided to fill it with sand. Because the removal of the locomotive and its cars would cost at least $30,000, far more than they were worth, railroad officials decided to bury them in the tunnel for all eternity. When the official decision to seal the train in the tunnel was made known, the *Richmond News Leader* recorded the train's obituary when it reported, "The train might not be seen for another geological epoch when men of a new civilization discover a relic of the Twentieth Century in what once was the blue marl of Church Hill."

Although the tunnel was closed, it was not forgotten. There were still occasional cave-ins and persistent concerns on the part of those people whose property was on, or near, the tunnel. Later on, children who did not know about that fatal day in October 1925 frequently saw the remains of the tunnel. A little girl named Lucille recalled going near the collapsed tunnel and picking up corncobs to burn in the family's fireplace. A daily trip for water at the spring at Chimborazo Park took a little girl named Evelyn close to the tunnel's eastern portal. Five-gallon jugs were placed in boxes, and boards were put between the jugs to keep them from breaking. After all these years, Evelyn can still recall the taste of spring water in a metal cup. In addition to being a place to get both corncobs and water, the closed tunnel was frequently mentioned in the papers to provide a geographical location of a fire or a crime. The memories of the tunnel have lingered from generation to generation.

Ralph Mason, the young man who had waited in vain at the tunnel for his father, worked for the C&O in Fulton Yard as a car inspector. Surely, he must have thought about his father as he worked along the same tracks that had carried his father's train into the Church Hill Tunnel. I met Ralph Mason many years ago, and he showed me Tom Mason's railroad watch, the same watch that he was carrying when the roof of the tunnel collapsed on his train. It was an emotional experience to look at the same watch that Tom Mason must have checked before leaving Fulton Yard on that rainy October day in 1925. I felt I had something sacred in my hands.

Tom Mason's grandson, Bill Mulligan, wrote this poem about the tunnel, transcribed here exactly as he wrote it:

We went to the tunnel that had caved in
It had taken the lives of four to hundreds of men.
The tale of how many never been told.
Of many men have died in that hole.
But I know it was more than four.
One was my granddad which was missed by family and friends.
They say the engine buried there will never see the light of day again.
Outside the hole sit a boy wet and cold.
Watching the men digging in the hole
He knew they were trying to save his dad

Life has its ups and downs.
They changed the boy's life around.
When his dad had died inside the hole.
He had to leave school to help his mother.
Raise his sisters and brothers.
And the time is closing on him and he has grown old
And maybe he will go to heaven to be with his dad his mother, sisters
and brother and all his kin
And they will be glad to see him.
And the Lord will take care of him.

Another poem was written by Llewellyn Lewis, a brakeman on the Southern Railway, in honor of his fellow railroaders who died in the Church Hill Tunnel:

"THE TRAIN THAT WILL NEVER BE FOUND"

Remember the Church Hill Tunnel
Near a mile under Richmond town—
There's a story I want to tell you
Of a train that'll never be found.

On a bleak afternoon in the autumn
When the skies were overcast
A train and its crew were working
In the tunnel performing their tasks.

No one dreamed of danger
Of a death that was hoverin' near
They were happy while they were working
For the loved ones home so dear.

When all on a sudden a tremble,
A large gap in the slimy clay—
Then the earth claimed a few in its clutches
In the darkness the rest groped their way.

Many shovels and picks were diggin'
For their pals in the buried train—
But the cold slimy clay held its victims,
Soon their hopes were found in vain.

Many hours did they search for their comrades
Who might live in the cold, cold cave,
But they never found one who was living
Way down in their untimely grave.

Brothers, keep shovelin'
Pickin' in the ground.
Brothers, keep listenin'
For the train that's never been found.

The train that has never been found and those who might still be buried with it in the Church Hill Tunnel are probably not recalled by those engineers who run the CSX trains within a few blocks of the tunnel. Yet I like to think that whenever a whistle blows on a locomotive, it is a tribute to Tom Mason, Ben Mosby, Richard Lewis and H. Smith and possibly other railroad men who joined that long line of those working on the railroad on an October day in 1925— those "who took their farewell trip to the Promised Land."

THE FLIGHT OF THE GOLD BUG: THE FIRST AIRPLANE TO FLY OVER RICHMOND

The airplane stays up because it doesn't have time to fall.
—*Orville Wright*

If you go outside at night and look up at the sky, you will see twinkling stars and, usually, the blinking red and green lights of an airliner carrying people to distant places. Indeed, it is hard not to see airplanes whenever you look into the sky. But the sky has not always been crisscrossed by blinking lights or the contrails of jets. There was a time when birds ruled the air and people could only dream of flying. These dreams became a

reality in 1903 when the first flight by a powered aircraft, designed by Wilbur and Orville Wright, took place at Kitty Hawk, North Carolina.

In the beginning, airplanes were curiosities, something to be seen at fairs and flown by daredevils. Such was the case when the first airplane flight took place in Richmond, Virginia, in 1909 at the Virginia State Fairgrounds. At the time of the first flight, the state fair was held where the Diamond baseball field is now located. The fairgrounds consisted of exhibition buildings, a grandstand and a mile-long racetrack. To make the area accessible at a time when horse-drawn carriages were the predominate means of transportation, the Seaboard Airline Railway operated special trains between Main Street Station and the fairgrounds.

Fairgoers had a lot to see in 1909, including farm products; farm animals; Minnehaha, the wild girl from Borneo; and Teddy, the smallest man on earth. But the main attraction was the Curtiss airplane (called the Golden Flyer or the Gold Bug) that was making the first flight of an airplane over Richmond.

The *Times-Dispatch* reported, "Aviation has invaded Richmond at last. Out in a large, white tent at the Fair Grounds stands the body of the world-famous Curtiss airplane, a long, box-like structure of light wood, canvas, and wire, the greatest mechanical achievement of the human mind." The airplane was powered by a twenty-five-horsepower motor with four cylinders. It had a 289-foot wingspan and was 33 feet long and weighed 550 pounds. The airplane's top speed was about forty-five miles per hour, and it was valued at $5,000.

Charles Foster Willard, the pilot, had been trained by Glenn Curtiss, a pioneer aviator and the founder of the Curtiss Aeroplane and Motor Company, now part of the Curtiss-Wright Corporation. A Harvard graduate, Willard, who held pilot license no. 10, commented, "We have mastered the air under certain conditions, but we have not mastered it under all conditions. Calm weather is required for flights, and a wind so slight that the average person would hardly notice it may be enough to prevent the ascent of the airplane." When someone asked him what an airplane did, he commented, "It just gets up into the air and goes."

History was made on October 4, 1909, at 5:30 p.m. when "the intrepid birdman" flew the airplane for the first time in Richmond, with about fifty thousand people anxiously watching the flight. It was

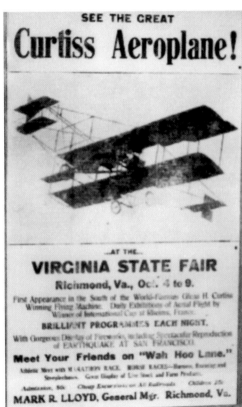

Above: The Gold Bug. *Author's collection.*

Right: State fair advertisement for the Gold Bug. *Courtesy of Richmond Newspapers Incorporated.*

reported that "the blades [propellers] whipped up a cloud of dust and trash, then the airplane glided gently down the field increasing its speed until, at the end of a hundred yards, it arose as gracefully as a bird and sailed along at an elevation of 12 feet before landing after a

flight of about 30 seconds and covering a distance of some 200 yards." The local paper reported that many people were not happy with the flight. It seems that people expected the "airplane to shoot straight up a mile or two into the blue, while others expected it to flap its wings like a colossal white bird." The newspaper, however, deemed the flight very satisfactory.

Flights were held for several days, and each day the local paper published a story about different aspects of them. One story focused on the pilot's preparation for the flight. The reporter wrote, "Mr. Willard took his seat. An assistant whirled the paddles [propellers] around. The aviator dropped his hand, and the machine started off gliding on its three wheels. The machine lifted its nose upward and entered into its element." Aother account described the takeoff as follows: "It rolled rapidly down the field, thousands of eyes straining to catch its every movement. For a hundred yards it kept to *terra firma*, and then it lifted slightly a few inches, gradually increasing the elevation with the uplift of its frontal planes until it was twelve or fifteen feet clear of the sod." It was noted that "there is always a hush before a flight, but the moment the airplane cleaves the air, lusty throats boom forth their approval."

A lot of spectators commented that the airplane landed somewhat like a chicken after a brief effort at being airborne. Unfortunately, on one flight, there was a minor accident, which rendered the airplane "helpless." While the airplane was being repaired, the crowd watched "dancing girls cavort." Since the state fair officials wanted to keep their main attraction available, efforts were made to limit the number of flights per day to avoid additional accidents.

When the state fair closed, spectators were left with the memory of seeing the first airplane fly over Richmond. But few of those who watched this flimsy, frail contraption could imagine a time when giant airplanes, like the Boeing 777, would speed down the runway when the pilot pushed the throttle forward. While the passengers and crew of the airplane would soon be flying at forty thousand feet, the people on the ground could only look up and wonder at the miracle of flight, one that Richmonders first saw in 1909.

THE KLINE KAR COMES TO RICHMOND

In design, material, and workmanship, the Kline Kar is not excelled.
—Kline Kar advertisement

While a college student, I drove a silver, bottom-of-the-line Corvair to the University of Richmond. With its engine in the back and trunk in the front, a stick shift and a heater that smelled of gasoline, it was a car I loved to drive, even though there were claims that it was "unsafe at any speed." Today, Corvairs are but fond memories and have joined the ranks of cars that are no longer manufactured, including Anchor Buggy, Auto Red Bug, Beaver, Cricket, Fox, Imp, Little Princess, LuLu, O-We-Go, Pup, Virginian, Walter, Zap, Zip and about 1,800 other makes that were sold in the United States between 1896 and 1930.

In the early years of the automobile industry, a number of cars were manufactured in Richmond, including the Coffee, which was described as a "smooth running car simple in its control and operation." Production of the Coffee began in 1902 and ended in 1903. Another Richmond product was the Cub Cyclecar, which was built from 1914 to 1915. Even less successful was the Henrico Car Company, which was organized in 1913 but probably did not manufacture a single car. The most successful car made in Richmond was the Kline Kar. Although Richmond was never considered to be the "Detroit of the South," the Kline Kar is a little-known piece of Richmond's history.

The story of the Kline Kar began when James A. Kline, a master mechanic, opened a dealership in Harrisburg, Pennsylvania, to sell cars, including the Locomobile, the curved dash Oldsmobile and the Franklin. Eventually, he left the business of selling cars to others and journeyed to York, Pennsylvania, to work on a car called the York that was later renamed the Pullman.

Using the knowledge he acquired in the car business, James A. Kline began building his own cars when he helped organize the B.C.K. Motor Company in 1909 in York. Two early Kline Kars were entered into dirt track racing competitions throughout the East, including the Virginia State Fair in Richmond. The success of these racers made the Kline name famous in the automobile business, especially in the eastern United States.

The attention attracted by the Kline Kar, both as a racer and as a fast seller in Virginia, persuaded a group of investors to buy the B.C.K. Motor Company and relocate it in Richmond along with its master mechanic James A. Kline. The factory was built on the Boulevard. The building was constructed of brick with a concrete foundation and floor. Its style was Colonial, and it was two stories high. Railroad sidetracks were constructed to permit the delivery of material to the factory. Completed in 1912, the factory had "Kline Motor Car Corp." on the front of the building. Immediately, the Kline Kar went into production, and the cars were sold in a salesroom at 322 West Broad Street.

Although the cars were built in Richmond, their engines were manufactured by the Kirkham Machine Company of Bath, New York, using a James A. Kline design. This was done to expedite production, which averaged about one thousand cars per year. Since they were built and styled by hand, Kline Kars were marketed as being of higher quality than mass-produced vehicles like Fords. Kline Kars used steel parts

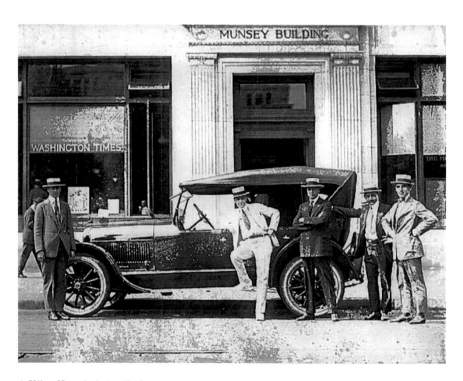

A Kline Kar. *Author's collection.*

to reduce weight and had electric starters to eliminate the dangerous task of hand-cranking a car to start it. In 1913, Kline Kars could be purchased with four- or six-cylinder engines that could produce up to sixty horsepower. Depending on the model, a Kline Kar could carry between two and seven passengers.

Kline Kar advertisements featured such slogans as "A Master Car for a Master Man," "Get the Best" and "The Value of Quality." Models included the following: Runabout, Limousine, Detachable Coup, Shamrock Roadster and Sedan Sport Touring. The cars sold for $2,500, which was considered expensive. Its main competitors were the Pierce Arrow, Duisenberg and Packard. (Henry Ford sold his cars for prices between $300 and $700.) The primary customers were "physicians or young men of fastidious taste." The car was also "popular among government employees in Washington, D.C.; and for some reason, it attracted buyers in the equestrian field." Although the car was of excellent quality, the company suffered numerous financial hardships in Richmond.

After coming out of receivership in 1915, the Kline plant was taken over by the United States government to make munitions during World War I. After initial postwar success, another recession struck and adversely affected the automobile market. Perhaps to better compete in the market place, the Kline Kars began to be mass-produced, with parts shipped from across the nation and assembled in Richmond, thus compromising its distinctive upscale character and quality reputation. The concept of an "assembled car," instead of a car with a lot of handiwork, did not please James A. Kline. The company manufactured about 2,800 vehicles before it ended production in 1923. James Kline lamented, "I would rather see my children [cars] dead than prostituted to cheapness and inferior workmanship."

The Kline Kar is a part of Richmond's history. The building where they were made has been replaced by the Greyhound Bus Terminal, but some old rusty railroad tracks can still be seen nearby. James A. Kline died in 1944 while serving as head of the American Automobile Association in Richmond. A 1918 Richmond-built Kline Kar, which was sold new for $2,000, has been preserved at the Virginia Historical Society, where a visitor can look at the car and dream of a time when the Kline Kars drove along the roads of Virginia with the spirit of James A. Kline behind the steering wheel.

Memories of Richmond's Horses

Oh, the old gray mare, she ain't what she used to be,
Ain't what she used to be, ain't what she used to be,
The old gray mare, she ain't what she used to be,
Many long years ago.

—author unknown

My grandfather operated a grocery store in Richmond's Church Hill. To make deliveries to his customers, he had a horse named Frank that pulled the grocery wagon. I was told that Frank was so intelligent that he knew the way to each customer's house from memory. This story from a bygone era serves as a reminder of a time when horses, not motor vehicles, provided transportation in Richmond and throughout the world. Today, the only horses seen in Richmond on a regular basis are the horses ridden by the Richmond Police Mounted Squad. But there are still a few reminders of those days of long ago when "old Dobbin" pulled a wide variety of delivery wagons with merchant names such as Richmond Ice Company, M.O. Feitig's Groceries or W.S. Collins' Transfer painted on the side. Other wagons included ambulances, buckboards, buggies, carriages, coaches, Hanover wagons, hearses, sleighs, sulkies and steam fire engines.

If you look carefully along Franklin Street and other streets in downtown Richmond, you will find some iron posts with iron horse heads mounted on the top. Horses were once tethered to these posts, which now serve only to bring back memories of times long ago. Also, you can still see mounting blocks in the front of some old Richmond homes. These large blocks were used to aid people in mounting horses or getting into carriages. More visible and imposing are the two horse water fountains that still serve the horses of the Richmond Police Department, as well as the occasional visiting horse.

The largest fountain is in Shockoe Slip. Starting out as a trading post, the Shockoe area has been used for various commercial enterprises for more than three hundred years. Although many of its buildings were destroyed during the Civil War, Shockoe was quickly rebuilt. The large fountain, constructed in a Renaissance style, was built in 1909 and replaced an earlier fountain. Its history is interesting.

Mrs. Elizabeth R. Morgan sent an undated letter to an official of the City of Richmond. In her letter, she wrote, "I wish to put up a drinking fountain for horses in Richmond as a memorial to my late husband Charles S. Morgan. I think that Shockoe Slip would be a good place to help workhorses since these horses were the sort Captain Morgan always gave his sympathy to." In her request to donate the fountain, Mrs. Morgan insisted that she did not want any publicity concerning the presentation of the gift. The City of Richmond accepted the fountain and, in its various ordinances, referred to the donor only as a "benevolent lady." The fountain has been described as "an octagon-shaped pool with a large bowl fountain in the center, from the sides of which five gargoyles drip water out of their mouths." It is inscribed as follows: "In memory of one who loved animals—Captain Charles S. Morgan, C.S.A., Inspector General Imboden's Brigade, Cavalry Divisions of General L. Lomax, Army of Northern Virginia."

The other horse water fountain was originally located in the center of a triangle formed by Broad and Adams Streets and Brook Road

The horse water fountain in Shockoe Slip. *Photograph by Walter S. Griggs Jr.*

before it was moved to its current location behind the Bill "Bojangles" Robinson monument. The circular trough is made of Maine granite trimmed in bronze and was, at one time, crowned with a streetlight (long since removed). Water trickles from its large bowl to four smaller basins near the bottom, providing water for cats and dogs that are too small to reach the part of the fountain used by horses. A plaque on the monument states: "1908—presented by the National Humane Alliance—Herman Lee Ensign—Founder."

Mr. Ensign, who died in 1899 in New York City, used his considerable fortune to donate at least one hundred of these fountains to various communities throughout the United States, some of which are still in use. It was hoped that these fountains would enable "man, horses, and dogs to drink for all time to come." Mr. Ensign believed that "[a]nimals were not merely inferiors or slaves, they were companions and friends, devoting themselves to man, and dependent on him for their lives and happiness."

As these two fountains were placed in Richmond, motor vehicles were being seen on the streets with increasing frequency. As motor vehicles replaced horses, one reporter wrote, "Night owls still see horses trudging along dragging milk wagons, but the romance of fire wagons and handsome carriages seems to have departed. Even the ice wagon horse has gone and with him the custom of kids hopping on and getting bits of cooling ice to eat in summer." When the transition from horses to motor vehicles was complete, my grandfather bought an orange Ford delivery truck, which replaced the ever-faithful Frank. Unlike Frank, the truck never learned how to get to the customers' houses from memory.

Those who donated the two fountains had a deep love of animals. This concern and compassion has continued with the annual service for the blessing of the animals that is held on a yearly basis at the Shockoe fountain. At this time, all animals, both great and small, are blessed with the hope that they can continue their work, whether it is patrolling a street, guiding a blind person or simply giving comfort by sitting next to someone who needs the feeling of being loved by a beloved dog or cat.

RICHMOND'S STEAM LOCOMOTIVE NO. 2732

*Headaches and backaches and all kinds of pain are not apart from a
railroad train;*
tales that are earnest, noble and grand are all in the life of a railroad man.

These lines from the "Ballad of Casey Jones" capture in verse the life
of a railroader in the days of steam. Although Casey was killed trying
to put his "engine in on time" in Mississippi, there are many tales
that can be told about Richmond's railroads. Richmonders can still
recall the collapse of the Church Hill Tunnel in 1925, can point with
pride to the famous three-level crossing (supposedly the only one in
the world) located at Sixteenth and Dock Streets and can remember
when the Science Museum of Virginia was Richmond's Broad Street
Station. Richmond has many links with railroading.

During the days of steam locomotives, when their mournful wails
echoed in the night, named trains like the George Washington, the
Champion and the Orange Blossom Special rumbled through Richmond
as they traveled across America. The Atlantic Coast Line, the Seaboard,
the Chesapeake & Ohio, the Norfolk & Western, the Southern and the
Richmond, Fredericksburg & Potomac all ran trains through Richmond
when steam ruled the rails and railroad engineers were folk heroes who
kept their trains on time by opening the throttle wide, straining their eyes
to see the "green board" and listening for the conductor's "All aboard."

Steam engines were like living, breathing, panting, pulsating creatures
that roared in and out of Richmond with their long lines of freight or
passenger cars. In time, the diesel engine consigned the steam engine to
the infamous scrapheap. Still, Richmond has not completely forgotten
the steam engine and its railroad heritage. The lonesome whistle still
blows, if only in memories.

In an effort to preserve the memories of steam railroading,
Richmonders placed Chesapeake & Ohio locomotive no. 2732 in
Travelland Park near the Diamond in 1960. If old 2732 could talk,
what a story it would tell.

Locomotive no. 2732 was built at the American Locomotive Works
in 1944. At birth, the locomotive weighed 851,000 pounds, measured
1,105 feet in length and was 15 feet in height. Locomotives like no.

2732 were called Berkshires by most railroads, but the C&O felt that such a designation was not appropriate for a locomotive with Virginia connections, so the C&O christened it Kanawha, the name of the West Virginia River it followed on many of its runs. Although the railroad called the locomotive Kanawha, the engineers who opened its throttle affectionately called it "Big Mike."

Since the locomotive was built during World War II, no. 2732's first assignments were to pull the long freight trains loaded with military supplies and troop trains that carried soldiers to the various ports of debarkation. Whether it was a Sherman tank or a sailor headed for a ship in Norfolk, Virginia, the powerful locomotive pulled the trains that helped to win the war. After the war, no. 2732 continued to pull the long, clanking freight trains and the endless coal trains, as well as the pride of Chessie's Road, the George Washington.

With bellowing smoke, hissing steam and screaming brakes, the locomotive raced back and forth across the C&O railroad network. Its pounding sixty-nine-inch drivers rolled on rails that laced the nation together in ribbons of steel—rails that formed spiderlike webs in freight yards, passed through small towns and large cities, cut through mountain passes and contracted in cold and desolate places where only a lonesome moose could see the train pass by. But in time, no. 2732 lost its place at the head of the train. It could not compete with the more efficient but less picturesque diesels. After steaming more than 300,000 miles in Virginia, West Virginia and Kentucky, no. 2732 was forcibly retired. Its fires were dropped forever.

When no. 2732 was placed in the park, Virginia governor J. Lindsay Almond said, "Old 2732, you are not dead. In the hearts of those who love you and your kind, you'll never die." Unfortunately, no. 2732 did not fare well in a public park. Children, ignorant of the danger, crawled all over the giant engine. It was said that children were going where experienced railroad workers would not have dared to go. Vandals assaulted the locomotive and tore off anything they could get loose as souvenirs. The once proud locomotive seemed destined to follow so many other steam locomotives to the scrapyard. But fortunately, no. 2732 was saved.

In 2003, the locomotive was moved to the Science Museum of Virginia to be preserved in a safe environment for future generations to see. Today, C&O Railway Kanawha Class K-4 stands silent and cold

while waiting for the call to service that will never come. An engineer dressed in blue overalls will never "mount to the cabin" and open its throttle. Still, with a little imagination, it is possible to remember no. 2732 as a magnificent steam engine that was once the pride of the C&O and a manifestation of American technology at its best. It is still possible to recall a time when glistening rails were pounded by locomotives that Native Americans called the "Iron Horses," that children called "choo-choos" and that those who can still dream called "beautiful."

On a personal note, I was a college student in 1960 with an exam scheduled on the day the locomotive was to be pushed along temporary tracks laid across the Boulevard. I took pictures of the locomotive before the move and after the move, but an exam kept me from photographing a Seaboard switch engine pushing no. 2732 across the Boulevard. Only a desire to graduate kept me from missing that ill-timed exam.

In 2003, I returned to watch as the locomotive was loaded onto a flatbed truck to be moved to its new location. This time I did not have any exams, but I had to go to a meeting at Virginia Commonwealth University. Once again, I saw the beginning and the end. But it was enough to know that old no. 2732 was safe and at rest.

WHEN RICHMOND WAS A CITY OF STREETCARS

Clang, clang, clang went the trolley
Ding, ding, ding went the bell
Zing, zing, zing went my heartstrings
From the moment I saw him I fell
　　　　—"Trolley Song," written by Hugh Martin and Ralph Blane

It has been over a half century since a streetcar rolled along the rails in Richmond, Virginia. Their sights and sounds are a rapidly fading memory now. But there are still a few reminders of the days when streetcars were the primary means of public transportation in Richmond: there is a streetcar at the Virginia Historical Society, a few concrete trolley poles remain on Grove Avenue, some tracks are still occasionally unearthed during street repairs and there is a brick shelter at the University of Richmond. Although the

streetcars no longer carry passengers in Richmond, one can still imagine a time when they were a major part of the city's transit system that enabled Richmond to expand and grow.

The story of Richmond's streetcars began before the Civil War, when horses and mules struggled to pull large coaches through the city's muddy streets. Called omnibuses, these coaches were described as stagecoach-like vehicles. They were cold in the winter and hot in the summer, and their floors were covered with the residue of well-chewed but misaimed tobacco. Eventually, rails were laid on the streets, and streetcars were constructed to run on the rails. This system provided a smoother ride for the passengers and an easier task for the horses and mules. When the Civil War erupted, the horses and mules were recruited to pull cannons for the Confederate army, and the rails were used as armor for Confederate ships. The war virtually destroyed public transportation in Richmond.

Following the Civil War, the horse-drawn cars returned to Richmond. Although historians did not record the names of all of the horses, a few of them have become a part of Richmond's history. Hairless Mary and Three Cents are remembered as horses that pulled streetcars up Ninth Street hill. But the horses were about to be replaced.

In 1887, the Richmond City Council authorized Frank Sprague, a graduate of the United States Naval Academy and an associate of Thomas Edison, and the Richmond Union Passenger Railway Company to develop an electrical railway system. On November 8, 1887, there was a test run. The streetcar jumped the tracks and ran into a marble pillar at Twelfth and Banks Streets. This was not a good start for Richmond's streetcars.

On January 9, 1888, car no. 28 left Twenty-ninth and P Streets in Richmond's Church Hill. Passengers paid a nickel for the ride. Unfortunately, the car failed and had to be returned to the shop for repair. Repairs were made and the problems were solved. By May 1888, streetcars were running along the tracks at a maximum speed of fifteen miles per hour. These streetcars had four wheels and were connected to an overhead wire by a device called a trolley. And a car with a trolley became known as a trolley car. The Richmond paper reported, "The cars were run regularly and very satisfactorily and greatly to the delight of the residents who had waited impatiently for the appearance, in their midst, of the horseless cars." These first streetcars were called "cheese boxes,"

and the slogan of the transit company was "No danger, no noise, and no smoke." Many authorities cite Richmond as having the first successful electrical streetcar operation in the United States.

Soon, streetcar lines crisscrossed the city along such routes as Ampthill, Ginter Park, Westhampton, Broad and Main, Jefferson, Belmont and Oakwood. On the streetcars were advertising signs, including Garden Week in Richmond, WRVA Radio, WLEE Radio, Light's Golden Jubilee and 25 Skidoo. From the inner city, the rails stretched out and new neighborhoods were developed, including Highland Park, Forest Hill, Fairmount and Ginter Park. No longer was it necessary to live in the inner city. A person could now work in the city and commute to and from one of the new surrounding communities by streetcar.

In addition to developing neighborhoods, amusement parks such as Reservoir Park (now Byrd Park), Westhampton Park, Forest Hill Park and Lakeside Park were developed by the transit company or made accessible by the clanging streetcars. On occasion, streetcars were chartered for special events and picnics by various groups, and they traveled to more distant points like Petersburg and Ashland.

One park that depended on the trolley was Westhampton Park in the west end of Richmond. Opened in 1902, a newspaper advertisement stated that the park had a merry-go-round, a dancing pavilion with a café and a shooting gallery. The park was apparently successful until the 1903 transit strike hurt patronage, and then it went into default. The property was eventually sold to the Country Club of Virginia and to the University of Richmond, which moved from its downtown location. The streetcars that formerly took people to an amusement park now took students to the University of Richmond, which was *not* an amusement park.

Naturally, the students had many comments about the streetcars. Both the men who attended Richmond College and the ladies who attended Westhampton College made many complaints about them. In 1914, the *Collegian*, the student newspaper, admonished students for putting their feet on the seats in the streetcars. A Westhampton lady commented that she did not like riding streetcars because people who smoked "exhaled into my newly-washed hair." Although Westhampton ladies who lived in Richmond could ride the streetcars to and from campus, the ladies who lived on campus had to get permission from the dean to leave the campus on the streetcar. In a later story, the students commented that the "grade of service is exceedingly

poor" but that the conductors and motormen were a "courteous, attentive collection of gentlemen."

During the years of World War II, a student complained about the shortage of automobile tires. Dr. T.E. Lavender of the University of Richmond faculty said that "students would have to resort to the trolleys." One student lamented that "streetcars made him sick." Another student complained that he would only have a car "until the end of this term and then I'll have to go on the streetcars."

Dr. Lewis F. Ball, a former English professor at the university, rode the streetcar as a student. He reflected that the streetcars were frequently jammed with students. Many students boarded the trolley at Ninth and Broad Streets and rode about forty-five minutes to get to the campus. On occasion, the students would actually have to use the switch bar to throw switches for the motorman since the crush of students did not permit him to leave the streetcar. If time permitted, some students would use the switch bar to crack walnuts on the rails. Dr. Ball recalled that sometimes students and others would pull the trolley off the wire, thus stopping the streetcar. In such cases, the switch bar was used to chase away the malefactors. The streetcars had to move slowly while in the city but were known to speed down Grove Avenue. Once in a while, one would jump the track as it rounded the curve at St. Stephen's Episcopal Church.

When World War II ended, streetcars were part of the celebration. In downtown Richmond, toilet paper was tossed over the trolley lines and caught fire. But the end of the war brought about the end of the streetcars that had carried so many people at a time when gas was rationed and tires were hard to find.

In 1947, the streetcar route to the University of Richmond was turned over to buses for a period of ninety days to test the feasibility of using buses. The streetcars never returned, and the tracks were covered over to create Campus Drive. However, the old trolley station still stands on campus, waiting patiently for a streetcar that will never arrive. And there is one more reminder of the streetcars. University of Richmond classes still start at 8:15 a.m. because the trolley arrived on campus at 8:00 a.m., and fifteen minutes were needed for students to reach their classes. Some things do not change at the University of Richmond.

Although Richmond had the first commercial streetcar line, it never updated its equipment to take advantage of the new cars that became

Richmond's last streetcar. *Author's collection.*

available after World War II. Instead, the transit company elected to replace streetcars with buses. Streetcars and buses coexisted until November 25, 1949, when streetcar no. 408 had its trolley pole lowered for the last time. A part of Richmond's heritage has been lost and the *clang, clang, clang* of the streetcar is no more.

RICHMOND'S MAIN STREET STATION

If you missed the train I am on
You will know that I am gone
You can hear the whistle blow a hundred miles

—*Hedy West*

Old railroad stations stand as monuments to a bygone era. They seem to be patiently waiting for a time when passenger trains will again come down the track behind a powerful steam locomotive with whistle screaming,

107

bell ringing, steam hissing, wheels squealing and smoke bellowing. These stations seem to expect that, some day, a conductor will shout "All aboard," and an engineer will slowly open the throttle on a massive steam locomotive. Once a source of civic pride, many of these old stations are now decaying relics of the golden age of railroads. Fortunately, Richmond's Main Street Station still stands untouched by the wrecking ball.

The story of Main Street Station goes back to 1899, when the *Richmond Times* published the plans for a new station in Richmond to serve the Chesapeake & Ohio and Seaboard Airline railroads. The station was to be built on the north side of Main Street between Fifteenth and Seventeenth Streets. The new depot was to be "one of the greatest improvements to Richmond in recent years." Indeed, it was described as "modern in every appointment, one of the handsomest stations in the country." Of French Renaissance style, it was to be a magnificent gateway to the city of Richmond.

Because of the frequent flooding of the nearby James River, the first floor of the station was built above flood level. Upon entering the first floor and buying a ticket, passengers could walk up the stairs or ride the elevator to the second floor, where they would board the trains. Trains entered the station under a massive train shed that was built behind the station. The third and fourth floors were for office spaces. To some, the station appeared to be a great chateau built in downtown Richmond.

Although the station was an instant Richmond landmark, its opening was without fanfare. On November 28, 1903, the *Richmond Dispatch* reported that the station was put into service "as quickly as possible." At 12:48 p.m., train no. 1 of the C&O Railway steamed into the station from Newport News, Virginia. The train was eight minutes late according to the clock in the station's tower. Even though there was no formal opening of the station, thousands of people were on hand to welcome the train. It was reported that with so many spectators at the station, the passengers had difficulty getting out of the railroad cars.

Those at the station commented that "the insistent cries of the hotel porters, backed up by the long line of hacks, carriages, and busses, gave one a clear idea that he was in a railway station, if there had been any doubt." Many of the spectators had left when the first Seaboard Airline train arrived from points south. Those who remained welcomed the train, which was carrying the first bridal couple to arrive at the station. The new station was now open for business.

A newspaper reporter, who was on the first C&O train to leave the station, wrote, "The shades of evening were falling as the train backed out of the train shed. Up and down Main Street could be seen numerous streetcars and the busy turmoil of the city's population hurrying through with the day's work." The reporter commented that "the engine's headlight [was] burning a way into the darkness that stretched to the westward where the sun had hidden behind the everlasting hills."

During the period of World War I, Main Street Station was filled with doughboys who were prepared to "go over there" to fight in the war. These were indeed sad days, as Richmonders left home to fight in a war that was supposed to be the "war to end all wars." Many of these young men would die in the trenches on faraway battlefields. Fortunately, my great-uncle Lewis Feitig went to France from Richmond but, apparently, did not see combat or have any religious experiences. He returned without any medals. (I am sure he must have done something heroic, but I just could not find out what he did.)

The horrors of war were compounded by another tragedy. The 1918 influenza epidemic took a frightful toll on Richmond and the nation. As the disease spread, coffins were stacked to the ceiling in Main Street Station waiting for trains to take the bodies to a final resting place. The great station became a place of deep despair and endless sorrow.

Following the war, the station welcomed those who had come home from overseas. Now the railroads prided themselves on powerful locomotives and well-maintained passenger cars. The sounds of "All aboard" and the excitement of vacationers were heard under the train shed as the trains steamed away to places of enjoyment rather than places of conflict.

It was in the summer of 1935 that Seaboard Airline trains called the Cotton States Special, the Southern States Special, the New York–Florida Limited and the Robert E. Lee were running in and out of Main Street Station. That summer, my parents boarded one of those trains to elope to Washington, D.C. My mother frequently told me that a conductor who was a neighbor saw them board the train. Although he spotted them, he promised not to tell anyone. Upon arriving home, he did tell his wife that there was going to be a wedding, but that was all he ever said. Their secret was safe as they rode the rails to the nation's capital.

Those were the glory days of the railroads. Passengers on the Seaboard's Robert E. Lee were promised "meals that appease air-

conditioned appetites, prepared in an inimitable savory fashion." Not to be outdone by its station neighbor, the C&O ran passenger trains named the George Washington and the Sportsman. These thundering trains glistened in the starlight as they sped across America from the coal fields of West Virginia to the massive buildings in New York City.

After the "day of infamy," many sad farewells were again said at Main Street Station as GIs boarded the trains to enter combat training. Tears of farewell could be seen as the long passenger trains, filled with soldiers, pulled away from the station. Because many soldiers needed transportation between Main Street Station and Broad Street Station, the Motor Corps of the Volunteer Service Bureau carried them between the two railroad stations. At Main Street Station, the United Service Organization set up recreation areas that provided games, magazines, stationery and ping-pong tables to give the soldiers something to do while they waited for the trains. So that sleeping soldiers would not miss a train, they were "tagged" with little pieces of paper that indicated the hour they were to be awakened by the gentle hand of a caring volunteer.

Main Street Station. *Photograph by Walter S. Griggs Jr.*

With the end of World War II, the soldiers once again returned on the trains and heard the conductor call "next stop, Richmond, Virginia." The passenger trains now returned to the business of carrying civilians, but the days of the passenger trains were drawing to a close. The airplane was rapidly replacing the train as the preferred method of transportation. Soon, fewer passengers came to Main Street Station.

The Seaboard Airline Railway left Main Street Station in 1959 and moved to Broad Street Station. Now alone at the station, the C&O Railway boarded up the first floor and built a small ticket office on the second floor. In 1975, the C&O abandoned the station. When the last train left the station, a band played "Auld Lang Syne." Thus, the old station was left to vandals and to fate. It was now but a house of memories.

Although the station was abandoned, it was not torn down. Repaired after two serious fires, in 1985 the building became a shopping mall known as the Marketplace at Main Street Station. This venture lasted a scant four years. Once again abandoned, the station was purchased by the Commonwealth of Virginia for office space.

Today, Amtrak trains have returned to the old station, and the bells, whistles and conductors' shouts once again echo through Richmond's Main Street Station.

RICHMOND'S BROAD STREET STATION

The rails go westward in the dark. Brother, have you seen starlight on the rails? Have you heard the thunder of the fast express?
 —Thomas Wolfe

Train stations hold memories. They are buildings that seem to hold time within their massive walls. Broad Street Station (now the Science Museum of Virginia) at 2500 West Broad Street in Richmond, Virginia, is such a place. By looking at the outside of the station, one can still imagine steam locomotives and diesel engines pulling passenger trains into and out of the station as they headed to points north and south. Walking through the station, one can still hear the wandering spirit of the conductor calling "All aboard" and see ghostly passengers walking down the enclosed concourse to their waiting trains, which now live only

in memory. This magnificent building is a monument to the time when railroads tied the nation together with steel rails and speeding trains.

Before the construction of Broad Street Station by the Richmond, Fredericksburg & Potomac Railroad, the railroad had used a series of stations. The first station was built in 1836 at Broad and Eighth Streets, and the trains ran up and down Broad Street, blocking streets and creating traffic hazards. Another station was built a few years later at Canal and Eighth Streets by the Richmond & Petersburg Railroad, which eventually became the Atlantic Coast Line Railroad. The two stations were not connected, which made it difficult for passengers to get from one station to the other. Passengers could pay for a ride or walk. The next station was at Broad and Pine Streets and was called Elba Station. This was the station that was serving the RF&P when the decision was made to move the station out of the downtown area to the western part of the city.

To plan for the new station, a design competition was held in 1913. John Russell Pope won the competition for the building of the station. Pope, who also designed the National Archives and Jefferson Memorial in Washington, D.C., modeled the station after the Parthenon in Rome and faced it with Indiana limestone. The Neoclassical station was designed to project the "railroad's reputation of rich elegance."

Ground was broken for the new station in 1917 at the site of the old Richmond Fairgrounds. At the time the station was constructed, the area was being used by the Hermitage Country Club as a golf course. After some delays, because of a shortage of workers due to World War I, the station was completed in 1919 and served passengers of both the Richmond, Fredericksburg & Potomac Railroad and the Atlantic Coast Line Railroad. Although the building had "Union Station of Richmond" chiseled on the front, it was always known as the Broad Street Station to distinguish it from the smaller Main Street Station that was used by the Chesapeake & Ohio and Seaboard Air Line railroads. The two stations were connected by streetcars for the convenience of the passengers.

The new station was inspected by Virginia governor Westmoreland Davis and his official party, who "expressed themselves as impressed with the splendid structure and its grounds and with the superior service of the restaurant." The general public was also quite impressed with the station when citizens were given the opportunity to tour it before the

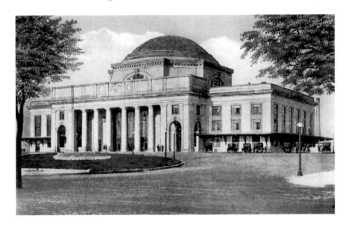

Broad Street Station. *Special Collection and Archives Virginia Commonwealth University Library.*

formal opening. There were many comments concerning the "ease and graceful approaches from the track to the main part of the station."

But the station was more than a place to "catch a train." Inside, the station had a restaurant, telegraph and telephone offices, lunchrooms, a barbershop and other conveniences. A special feature was a "great illuminated sphere, representing the world," suspended from the domed ceiling of the huge waiting room. The Richmond paper reported "that those who come [to visit] are assured that they will see a structure which, with its surrounding grounds, forms a depot that is not surpassed south of Washington."

Broad Street Station was opened on January 6, 1919, at 12:01 p.m. Fourteen minutes later, the first train from the north steamed into the station. It was no. 9, a local from Washington. The first train to depart the station was RF&P no. 70, scheduled to depart for Washington at 12:40 p.m. The station was now alive with the sights and sounds of the massive steam engines and the comings and goings of the passengers.

Within a week of its opening, the station welcomed its first celebrity when the evangelist Billy Sunday arrived to start his Richmond crusade. Leaving the train, the evangelist "ran up the incline that led from his train, mounted a radiator, and proclaimed, 'We are here.'" A choir responded with a chorus of hallelujahs. Most of the passengers were generally not greeted with hallelujahs but were warmly welcomed by those waiting for them in what was being called a "jewel among railroad stations."

Richmond's jewel was home to steam engines named for Virginia governors, Confederate generals and distinguished statesmen and pulled passenger trains named Champion, Havana Special, Everglades and

Florida Special. When these trains came into Broad Street Station, the conductor would announce, "Next stop: Richmond, Virginia."

Then the world changed forever. On December 7, 1941, the Japanese attacked Pearl Harbor, and Broad Street Station became filled with men and women in their nation's uniforms riding the trains to military camps and ports of debarkation. The station was at once a place of both sadness and joy as young men and women left Richmond to face an uncertain future and then safely returned from places like Normandy, Iwo Jima and Midway. On April 22, 1943, more than thirty-three thousand passengers on sixty-four trains passed through the station. This was the station's all-time record of usage.

The end of the war brought many returning men and women to Richmond. Two of the most famous arrivals came in March 1946 when Winston Churchill, Britain's wartime prime minister, arrived by a special train at Broad Street Station. The *Richmond News Leader* reported that the "72-year-old Briton came sleeping into the city aboard a five-car train from Washington." On the same train, but in a separate car, was General Dwight D. Eisenhower. The two World War II heroes visited the city to speak to the Virginia General Assembly. Although these men arrived by train, train travel was about to be eclipsed by air travel.

Airplanes were becoming the most popular mode of traveling, and this started a reduction in rail passenger travel. More and more passenger trains were removed and were becoming fond memories. The era of the steam engine was about to end. On January 4, 1954, RF&P locomotive no. 692, named Carter Braxton, arrived with a southbound passenger train from Washington. With its arrival, the steam locomotive passed into history, to be replaced with sleek RF&P diesel engines painted blue and gray. But even more changes were in store for Broad Street Station.

The Seaboard Air Line Railway began to run its passenger trains into and out of Broad Street Station, instead of Main Street Station, in 1959. The Seaboard brought its named trains like the Silver Meteor and its classic Tavern Observation Cars into the station, but fewer and fewer passengers were riding the trains.

In an effort to save the passenger train, the RF&P inaugurated the Blue and Gray Clipper, which provided fast service to Washington, as well as special trains to theaters in New York City and to Washington Redskins football games. Also of fond memory was the Santa Claus train for children and their parents that featured visits with Santa. Even with these efforts,

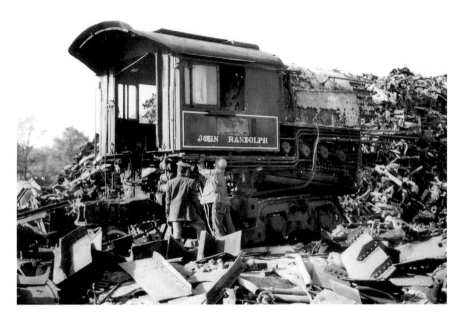

The end of the line for a Richmond, Fredericksburg & Potomac locomotive in the junkyard. Its last run was to Broad Street Station. *Photograph by Walter S. Griggs Jr.*

passenger service continued to decline. By 1970, only about two thousand passengers a day were using the station, and its many shops were closed. They had been replaced by vending machines. The age of the passenger train was ending, and they no longer needed their "home" on Broad Street.

Amtrak began operation on May 1, 1971, and more changes were in store for the station. By 1972, only two trains per day used the station, and Amtrak planned to consolidate operations at a new smaller terminal outside Richmond.

November 15, 1975, was a sad day when train no. 88, the Meteor/ Champion, departed at 4:45 p.m. bound for New York. The magnificent station now stood empty; the sounds of the railroad had passed into history.

Whenever I see the station, I recall my first train ride. I was at Ginter Park School in the second grade on May 18, 1949. My class arrived at Broad Street Station for our trip to Petersburg. I recall walking by the Norfolk Western steam locomotive and hearing it hiss. I also remember that the train backed into Petersburg. Years later, I was heading back on the train from a meeting in Florida; it was the night Dr. Martin Luther King Jr.

was buried. Somewhere between Florida and Richmond, someone started shooting into the train. The conductor ordered all of the passengers to get on the floor. I felt like I was in the Old West being attacked by the James brothers. Later, I learned that a shotgun blast had hit the diesel engine.

Memories still linger of my brother going to Broad Street Station and heading to Yale University. Four years later, I recall leaving very early and riding the train to his graduation and wondering why some passenger who boarded the train north of Richmond was dragging a very large cross through the car. And there was the time I was going to Washington on the RF&P and saw a couple of handcuffed gentlemen riding in the car with me. There was also a man sitting with them who seemed devoid of any sense of humor. I am still wondering what those two gentlemen had done to merit a train ride in handcuffs.

My biggest thrill occurred when I was invited to ride on Atlantic Coast Line locomotive no. 534 by engineer Mac MacManaway as he prepared to leave from Broad Street Station. I can still recall the engineer and fireman repeating "Red Board" to each other, as well as how sturdy the locomotive seemed to be when compared to my Corvair, which I had driven to the station.

Unlike many stations, Broad Street Station was not torn down when the trains left. There were many proposals for the future use of the structure, including a community center, a state office building, a transportation museum or a science museum. The museum proposal prevailed, and today the former station is home to the Science Museum of Virginia. But amid the many interesting exhibits, the spirits of those who rode the rails many years ago can still be felt within the station's walls.

THE TRAIN OF TOMORROW COMES TO RICHMOND

Go-na pack my grip for a nice long trip,
Go-na beg, buy, steal or borrow,
Go-na make my home in the astrodome,
In the wonderful Train of Tomorrow.

I was only six years old when the Train of Tomorrow came to Richmond on July 8 and 9 in 1947. My only memories of the visit to the train with

my father are looking out of the domes on top of the cars, getting a brochure and learning how the engineer blew the whistle. Except for these few things, I can remember nothing else about this train that helped to revolutionize passenger train service in the United States.

The Train of Tomorrow was conceived during a train ride in the diesel cab of a freight locomotive during World War II by Cyrus R. Osborne, general manager of the General Motors Electro-Motive Division. He was captivated by the beautiful scenery he could see from the diesel locomotive's cab and from the cupola of the caboose. The idea of the Train of Tomorrow was born when Osborne remarked, "If the traveling public only knew what they could see from the cab of a diesel locomotive or the copula of a caboose of a freight train, the railroads could sell seats in these two places at $500.00 apiece and always keep them full." Then he asked, "Why wouldn't it be possible to build some sort of glass-covered room in the roof of a [passenger] car so travelers could get this kind of view?"

Following the end of World War II, General Motors entered into a contract with the Pullman Standard Company to build a state-of-the-art passenger train. The E7A diesel locomotive was built by General Motors and was a standard production locomotive with a few cosmetic additions. Designed by General Motors as a "rolling laboratory," the train was first called the Astra-Liner. The total length of the train, including the locomotive, which was painted blue and silver, was 411 feet, and it had a passenger capacity of 216.

The locomotive pulled four state-of-the-art passenger cars with domes from which passengers could see the world pass by. The first car, named Star Dust, was a chair car that could accommodate seventy-two passengers in "gloriously restful, reclining seats, individually lighted." The next car was the Sky View, the dining car, which provided all of "the advantages of roof garden dining—fine food, glamorous atmosphere, and superb views." The sleeping car was the next car on the train and was appropriately named Dream Cloud. The last car, named Moon Glow, had cocktail lounges and telephone service.

On a test run, a phone call was made from the Train of Tomorrow to the ocean liner RMS *Queen Elizabeth* that was sailing in the Atlantic Ocean. During the conversation, the ocean liner's captain wished the train and its crew a successful tour. After this test run, the train was moved

to a track near Soldier's Field in Chicago for the christening ceremonies. Jane Kettering, the granddaughter of C.F. Kettering, a General Motors executive and inventor, moved a device that started the locomotive's engines. She then smashed a bottle of champagne against the ladder to the engineer's door of the locomotive. Following the ceremonies, the train left Chicago for what would be a sixty-five-thousand-mile trip, with stops at almost two hundred cities in both the United States and Canada. Before the tour ended, almost 6 million visitors would tour the train.

The train departed Chicago on June 2, 1947, and after stops in Detroit, Akron, Pittsburgh and Atlantic City, it arrived and was put on display in Fredericksburg, Virginia, on July 8, 1947. While the train was in Fredericksburg, the Richmond papers carried a large advertisement announcement: "General Motors invites you to visit this blue and silver herald of future rail progress on display at Richmond, Fredericksburg & Potomac Railroad's Ballpark Freight Yard, Allen Avenue and Broad Streets, [in Richmond, Virginia], Tuesday, July 8, [1947], 6 p.m. to 9 p.m. and on Wednesday, July 9, [1947], 2 p.m. to 9 p.m." (No longer in existence, the Ball Park Yard was named for a baseball park that used to be located at Allen and Broad in the 1890s.)

The paper further reported that the Train of Tomorrow was an "elegant rail conveyance" featuring four cars containing "the most progressive and stimulating ideas ever developed for the comfort, convenience, and pleasure of rail travelers." The advertisement called attention to the "32-foot glass-enclosed observation deck nestled in the roof of each car giving passengers a glorious, panoramic view of the passing landscape." When the train left Fredericksburg, it carried dignitaries from across the Commonwealth to Richmond.

Several stories were written about the train by Richmond reporters. It was pointed out that each car on the train was unique. One reporter quoted an elderly lady who proclaimed, "Thank goodness the new trains have improved the indecent sleeping conditions. Why, on the old trains, one either paraded the aisle in your dressing gown or sprained your back trying to change clothes in your berth." Another visitor liked the "solid walls which replaced the old curtains through which many an unwanted midnight visitor had lurched inadvertently." Many Richmonders commented about the "glass dome above the car level which enabled the traveler to see the world." One visitor even suggested "the [view from

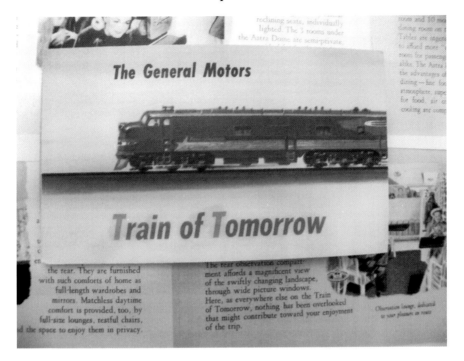

A Train of Tomorrow brochure. *Author's collection.*

the] astra domes might be an incentive for cleaning up the American landscape." The telephones on the train would enable the "traveling lady to call home and remind her husband to be sure to feed the puppies and pick up the laundry." And it was noted that because the diesel engine did not expel clouds of smoke, ladies "could travel in light-colored clothes."

After it left Richmond, the Train of Tomorrow continued to tour the United States and parts of Canada. Many celebrities of the time rode the train, including Art Linkletter, Ginger Rogers, Herbert Marshall, Walter Pidgeon and Ann Southern. Rin Tin Tin, the famous dog actor, also visited the train and left a "reminder" of his visit on one of the wheels. Following its tour, the Train of Tomorrow was sold to the Union Pacific Railroad, where it became known as the City of Los Angeles. Today, only the Moon Glow still exists and is in storage until such time as it can be restored to its former glory and remind people of the Train of Tomorrow and its great influence on the passenger trains of today.

Although the Train of Tomorrow has passed into railroad history, Amtrak passenger trains still roll across America. From their large windows,

you can see the United States pass in review; with a little imagination, you can see Pony Express riders, covered wagons, the United States Cavalry on patrol and, perhaps, the ghost of the Train of Tomorrow.

WAITING FOR A TRAIN

I heard that lonesome whistle blow.

—Hank Williams

In writing about Richmond, I have come to realize that everything changes. Old buildings are replaced by new ones, new residential areas are developed, schools are built and huge shopping centers spread across the landscape. Trees come down and buildings go up. Squirrels scatter and roads are built. And little bluebirds have to find a new place to nest. Everything seems to change.

While finishing this book, I decided to visit some of my favorite train watching spots to recall the memories of the many times when I sat near the tracks and hoped that a train would come along so that I could photograph it.

My first stop was R Cabin, which is located in the Fulton Railroad Yard. Thanks to my friend Don Cornell, I spent many hours in R Cabin taking pictures of trains going and coming through the yards. Steam was gone when I took my pictures, but you could still see some of steam locomotives waiting for the scrap heap, the coal tipple and the large roundhouse. You could also see men standing on top of boxcars, which is no longer permitted.

When I returned to R Cabin, it was boarded up, no longer being used. A victim of modernization, it seems destined to be demolished in the near future. No one will ever know how many trains passed this cabin in the more than one hundred years it has been in use or how many tired trainmen knew that they were almost home when they saw it. As I left Fulton Yard, I realized that one of my favorite train watching sites was no more.

Next, I went to the site of the C&O's Westhampton Station. Unlike R Cabin, it has been moved to another location, but its future could well be in doubt as well. As I looked at the site of its former location, I could

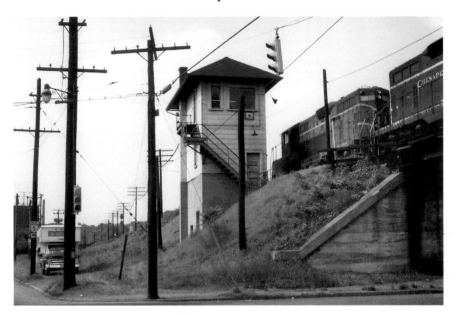

R Cabin, Fulton Yard, circa 1960s. *Photograph by Walter S. Griggs Jr.*

Westhampton Station and C&O locomotive no. 2732 at its former location in Richmond's Travelland Park. *Photograph by Walter S. Griggs Jr.*

Engineer K.A. MacManaway leaving Richmond. *Photograph by Walter S. Griggs Jr.*

imagine the ghosts of people long gone standing in line waiting for a train to take them the last ten or so miles into Richmond. Small train stations are rapidly becoming things of the past. Once again, I learned that another favorite train watching location was no more.

Finally, I went to a place near Windsor Farms where I used to watch the Atlantic Coast Line trains leave Richmond. There was something special about this spot because engineer K.A. MacManaway would always wave and blow the horn of the diesel as he sped by. Over the years, I took more than one hundred pictures of this engineer running trains for the Atlantic Coast Line and then the Seaboard Coast Line. I will never forget those waves and the sounding of the horn. But my spot is no longer accessible. The Downtown Expressway destroyed my little place by the side of the tracks. But no highway can ever make me forget Mr. Mac and those speeding trains filled with people or merchandise headed to Florida and other points south.

Richmond has changed, but I guess I am about the same. My love of history only increases as the years pass by, and I stand in awe of the growth of the city of Richmond, a place I will always call home.

BIBLIOGRAPHY

BOOKS

Behr, Edward. *Prohibition: Thirteen Years That Changed America*. New York: Arcadia Publishing Company, 2011.

Christian, W. Asbury. *Richmond: Her Past and Present*. Richmond, VA: L. H. Jenkins, 1912.

Dabney, Virginius. *Richmond: The Story of a City*. Charlottesville: University of Virginia Press, 1990.

Davis, Burk. *Jeb Stuart: The Last Cavalier*. New York: Random House, 1957.

Dictionary of American Naval Fighting Ships. Washington, D.C.: United States Naval History Division, 1981.

Dorsett, Lyle W. *Billy Sunday and the Redemption of America*. Macon, GA: Mercer University Press, 2004.

Freeman, Douglas Southall. *R.E. Lee*. New York: Scribner's Sons, 1934–35.

Griggs, Walter S. *The Collapse of Richmond's Church Hill Tunnel*. Charleston, SC: The History Press, 2011.

———. *General John Pegram, C.S.A.* Lynchburg, VA: H.E. Howard, 1993.

Hatcher, William. *John Jasper.* New York: Revell, 1908.

Holland, Kevin J. *Classic American Railroad Terminals.* Osceola, WI: MBZ Publishers, 2001.

Kimes, Beverly Rae, and Henry Austin Clark. *Standard Catalog of American Cars.* Fairfield, OH: Krause Publications, 1996.

Lord, Walter. *A Night to Remember.* New York: Holt, 1955.

Lundstrom, John. *First Team: Pacific Naval Air Combat from Pearl Harbor to Midway.* Annapolis, MD: United States Naval Institute Press, 2005.

Lutz, Francis Earle. *Richmond in World War Two.* Richmond, VA: Dietz Press, 1951.

McKenney, Carlton. *Rails in Richmond.* Glendale, CA: Interurban Press, 1986

McLaughlin, William B., Jr. *Billy Sunday Was His Real Name.* Chicago, IL: University of Chicago Press, 1955.

Morgan, Ric. *The Train of Tomorrow.* Bloomington: Indiana University Press, 2007.

Morison, Samuel Eliot. *Christopher Columbus: Admiral of the Ocean Sea.* Boston: Little, Brown and Company, 1942.

Richardson, Selden. *The Tri-State Gang in Richmond.* Charleston, SC: The History Press, 2012.

Robertson, James I. *Stonewall Jackson.* New York: MacMillan Publishers, 1997,

Rosen, Robert N. *The Jewish Confederates.* Columbia: University of South Carolina Press, 2000.

MISCELLANEOUS MATERIAL

Cannon Memorial Chapel, Archives, Boatwright Memorial Library, University of Richmond, Virginia.

Elizabeth Morgan Papers, Archives, Richmond History Center.

John D. Wingfield Papers, Archives, Alderman Library, University of Virginia.

Railroad Clipping File, Richmond Public Library, Richmond, Virginia.

Rarely Seen Richmond, Virginia Commonwealth University Library.

Richmond City Auditorium, Archives, Virginia Commonwealth University Library.

PERIODICALS

Daily State Journal, May 10–17, 1873.

Richmond Dispatch, July 29, 1890; August 6–7, 1890; August 9, 1890; August 12, 1890; August 17, 1890; September 3–4, 1890; and October 17, 1890.

Richmond Times-Dispatch, October 1, 1909; October 2–12, 1912; December 9–10, 1927; March 9–11, 1934; October 4–5, 1934; February 2, 1935; February 3, 1936; March 17, 1942; and November 25, 1949.

Times-Dispatch, April 16–19, 1912; April 22, 1912; April 26, 1912; April 29, 1912; and May 2, 1912.

ABOUT THE AUTHOR

Dr. Walter S. Griggs Jr. is a professor at Virginia Commonwealth University in Richmond, Virginia, where he teaches law. He has also taught history courses in the Honors College. He holds a master's degree from the University of Richmond, a juris doctorate from the University of Richmond School of Law and a doctorate from the College of William and Mary in Virginia. Griggs has written books on the Church Hill Tunnel (published by The History Press), the Civil War and moose, as well as numerous academic articles. He was awarded the Jefferson Davis Medal for his Civil War articles and books. For more than thirty years, he has written articles for the *Richmond Guide*, a local tourist magazine, on various subjects pertaining to local history. Griggs is married to the former Frances Pitchford, who, fortunately, is a retired English teacher. She edits and proofs his work. He is equally fortunate to have a daughter, Cara, who is an archivist for the Library of Virginia. Walter Griggs and his family live in Richmond.